EXPOSED / A HISTORY OF LINGERIE

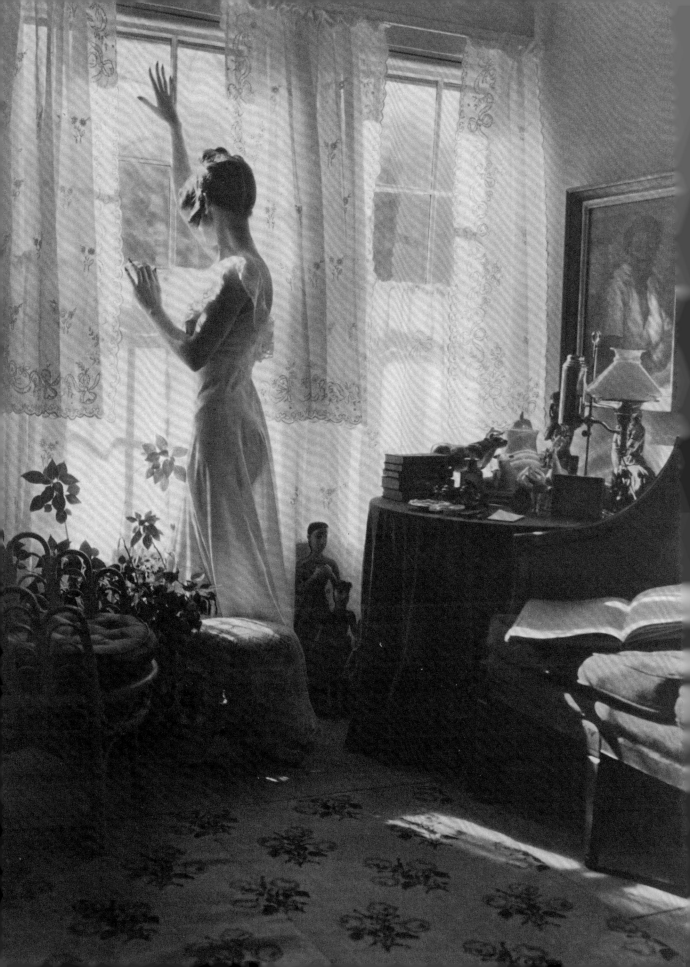

EXPOSED / A HISTORY OF LINGERIE

Colleen Hill
Introduction by Valerie Steele

YALE UNIVERSITY PRESS / NEW HAVEN AND LONDON IN ASSOCATION WITH
THE FASHION INSTITUTE OF TECHNOLOGY / NEW YORK

Designed by Paul Sloman and Guy Powell / +SUBTRACT

Printed and bound in Italy at Conti Tipocolor S.p.A.

Library of Congress Control Number: 2014940298
A catalogue record for this book is available from The British Library

FRONTISPIECE/

Louise Dahl-Wolfe, Model Betty Bond wearing a nightgown by Fisher. Detail.
Harper's Bazaar (April 1942): 42.
Collection of The Museum at FIT, 74.84.255
(Gift of Louise Dahl-Wolfe)

CONTENTS /

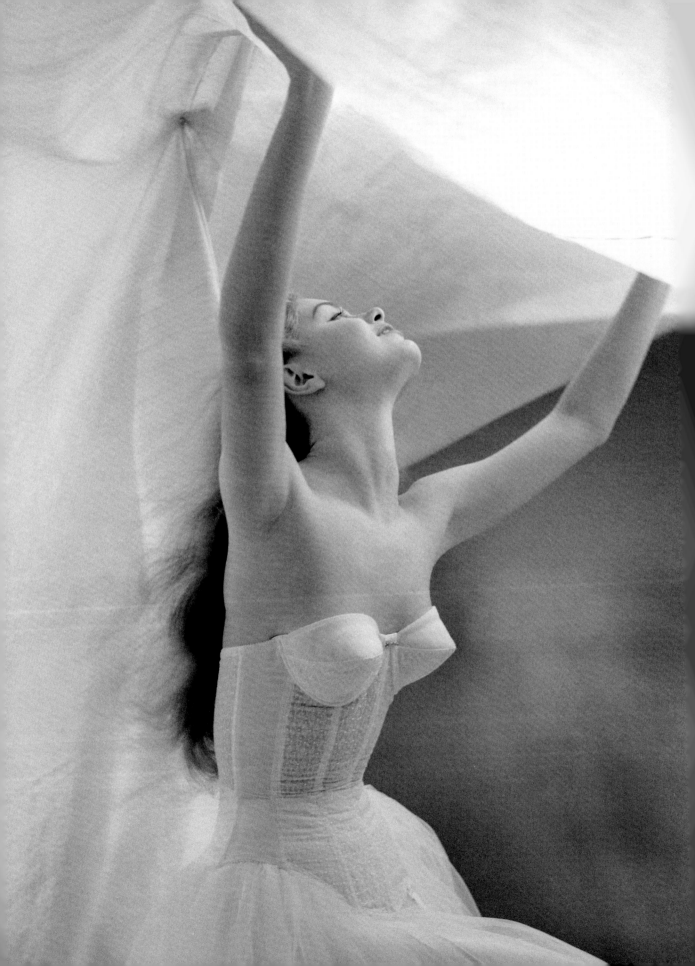

A SECOND SKIN / *VALERIE STEELE*

> *There is no finer, richer, more beautiful fabric*
> *than the skin of a pretty woman.*
> – *Anatole France*[1]

Lingerie is secret, sexual clothing; it touches the naked body and, like the body, it lies hidden beneath the outer layers of dress – to be revealed only under intimate circumstances. The sexual allure of the body "rubs off" onto the silky fabric that veils it, but this veil also contributes an erotic charm of its own, involving the attraction of concealment and mystery. Within the modern apparel industry, underwear is referred to as "intimate body fashions." Of course, all clothing is worn on the body, but the more intimate the connection between body and clothes, the more erotic the clothing will seem.

Fashion, especially lingerie (women's underwear), has often been compared to a second skin. This metaphor alludes to the tactile eroticism of soft skin and silky fabric. It also implies that a woman wearing only lingerie is simultaneously dressed and undressed – or that she appears to oscillate between the two states, embodying a continual striptease. In his 1883 novel *Au Bonheur des dames*, Émile Zola described the lingerie on display in a department store, saying that it looked "as if a group of pretty girls had undressed . . . down to their satiny skin."[2]

There are two types of lingerie: soft and hard. Soft lingerie includes drawers (underpants), chemises (slips), petticoats, stockings, nightgowns, camisoles, unstructured brassieres, and so on. Hard lingerie includes corsets (stays), girdles, hoops such as crinolines and bustles, and structured brassieres. For more than four centuries, women wore corsets or

BARBARA CURLY, EARLY 1950S
Barbara Curly, early 1950s (advertisement for La Roche).
Photograph by Lillian Bassman.
Courtesy of the estate of Lillian Bassman.

"whalebone bodies" – *corps à baleine* – a revealing expression that blurs the line between the body itself and the structured undergarment that embraces and shapes it. Édouard Manet, whose painting *Nana* (1877) shows the actress Henriette Hauser wearing a blue satin corset and silky white iingerie, once suggested that "The satin corset may be the nude of our era."[3] The corset has played a particularly significant role in the complex and ambiguous eroticism of women's underwear, but all types of lingerie have aroused desire.

"Lingerie is an enthralling subject," declared the English fashion writer Mrs. Eric Pritchard.[4] Indeed, she went so far as to argue, somewhat blasphemously, that "The Cult of Chiffon has this in common with the Christian religion – it insists that the invisible is more important than the visible."[5] Nor was she alone in her enthusiasm, for the period from 1890 to 1910 has often been described as the great era of lingerie, and many writers devoted attention to the subject. Museum fashion collections support the argument that decorative and luxurious lingerie became much more prevalent late in the nineteenth and early in the twentieth century. But this raises several questions. Why did lingerie become such an important part of fashion at the turn of the century? What was women's underwear like in previous generations? And what significance does lingerie have for us today?

"The most special characteristic of contemporary dress is the elaboration of undergarments," wrote the pioneering French fashion historian Octave Uzanne.[6] The "exquisite, adorable art" of elegant, luxurious lingerie developed, he argued, in direct proportion to the increasing "simplicity and severity of day clothes." Over the last quarter of the nineteenth century, the majority of women adopted a "democratic uniform" popularized by the department stores, while even the most stylish women focused on looking *comme il faut* (correct). In contrast to earlier eras, when women paid attention only to the splendor of their outer clothing, the modern woman resembled "certain books bound in 'Jansenist' style, without ornaments." The popular "English-style tailored suit," in particular, exemplified the sobriety of the fashionable exterior. Lingerie seemed to be the last repository of femininity in the age of the New Woman. Or as Uzanne put it, lingerie was "the last mythological expression of woman."[7]

EDOUARD MANET, NANA, 1877
Edouard Manet, *Nana*, 1877. Detail. Kunsthalle, Hamburg.
(Photo: bpk, Berlin / Hamburger Kunsthalle /
Elke Walford / Art Resource, NY)

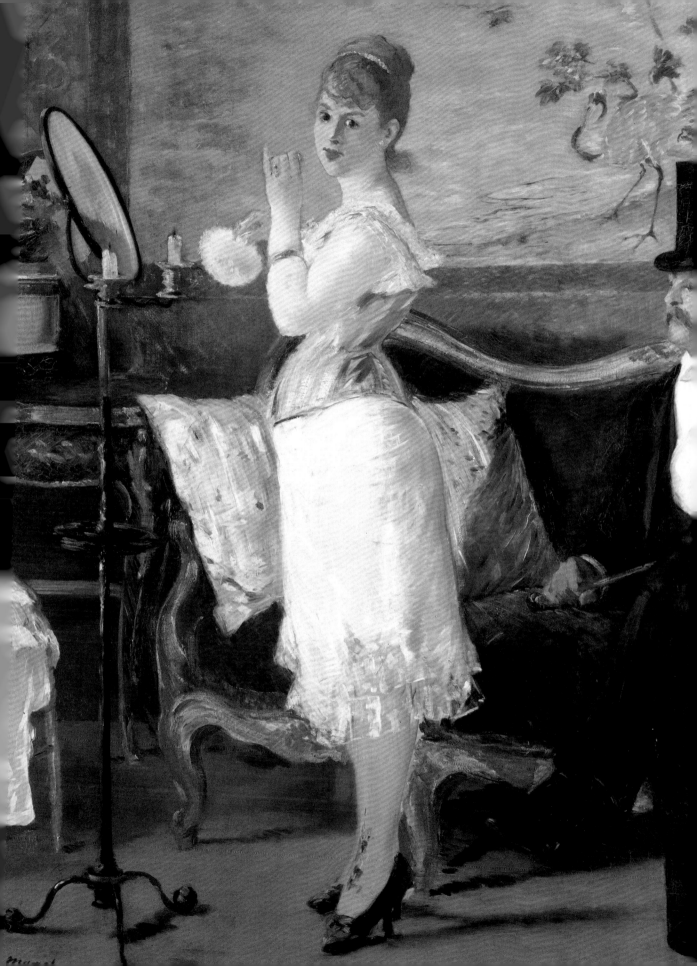

Although Uzanne accurately observed a correspondence between sober daytime dress and the flourishing of luxurious lingerie, did the former really *cause* the latter? The tailored suit may have been a quasi-masculine style (and it was certainly perceived as such, especially in France), but fin-de-siècle evening dress reached new heights of femininity – and evening dress was also worn with exquisite, beautiful lingerie. Moreover, while certain categories of lingerie unquestionably became more luxurious, decorative, and erotic, others, such as lingerie designed for sporting activities, became more practical. Indeed, lingerie simultaneously evolved in two directions: toward greater luxury of materials and decoration, and also toward greater functionalism. If practical underwear reflected women's growing interest in sports and their integration into modern, urban life, the increasing emphasis placed on luxurious lingerie was an expression of a new attitude toward sexuality.

Courtesans were, naturally, the first to wear luxurious and seductive lingerie. When Manet's *Nana* was first displayed, one reviewer observed that "The aristocracy of vice is recognizable today by its lingerie."[8] But in her popular book *Le Bréviare de la femme* (1903), the comtesse de Tramar insisted that respectable married women were wrong to think that exquisite lingerie was "reserved only for those whose profession is to seduce." She believed that "The husband has the right to see pretty things" – "elegant and gay" lingerie was as important as "good silver" or "a well-decorated house." The modern wife was not only a good housekeeper and mother, she was a lover, who knew that fine lingerie was of "essential importance": "It is the veiled, secret part, the desired indiscretion conjured up; the man in love expects silky thrills, caresses of satin, charming rustles, and is disappointed by an unshapely mass of rigid lingerie . . . It is a disaster!"[9]

Mrs. Pritchard even blamed failed marriages on the wife's unwilling-ness to adopt more seductive lingerie and, by extension, a more seductive attitude toward her spouse: "Can one wonder that marriage is so often a failure, and that the English husband of such a class of women goes where he can admire the petticoat of aspirations?" She advised "the irreconcila-bles among my married friends not to shriek loudly with the company of disappointed spinsters . . . but to try . . . the expedient of a much-befrilled petticoat or some illusions in *robes de nuit*."[10] "Nothing equals the voluptuous power of feminine underwear," declared the baronne d'Orchamps in her book *Tous les Secrets de la femme* (1907): "At the apparition of these veils . . . an ineluctable rapture . . . comes over the masculine brain."[11]

Predictably, fashion writers maligned the underwear of the past: "Think of the old days, when the bulky flannel petticoat [and] thick long-clothes . . . were *de rigeur*."[12] Historically, of course, underwear *had* usually been quite simple, especially in comparison with often ornate outer clothing. For centuries, in medieval and early modern Europe, both men and women wore plain, T-shaped undergarments, usually made of linen. Women wore a long shift (later known as a chemise and the precursor of the modern slip) and men wore a shirt and underpants. Apart from providing warmth and a softer surface against the skin, the primary purpose of these undergarments seems to have been to protect clothing from the dirt and sweat associated with the (seldom washed) body.

To the extent that the undergarments of ruling-class men and women were visible, they were decorated. Men's shirts often had decorative lace collars and cuffs, and, in the eighteenth century, women's stays and petticoats could be lavish. By the nineteenth century, however, as standards of modesty became stricter, underwear was increasingly hidden. Since this "invisible" layer of clothing was supposed to reflect the wearer's sense of propriety, most soft lingerie and most corsets were made of white fabric, with perhaps a little decoration in the form of lace or embroidery. As one French medical doctor wrote in 1861, "A woman's chemise is something to respect . . . White symbol of her modesty, it must not be touched or observed too closely."[13]

In *Fashioning the Bourgeoisie*, Philippe Perrot observes that, although one might think that bourgeois modesty would "logically" have led to the rapid introduction of women's drawers (underpants), this was not the case. Quite the reverse: underpants were thought of as disturbingly masculine, and for many years they were worn only by young girls and by dancers, actresses, and courtesans. It was only when the cage crinoline came into fashion (increasing the danger of inadvertent exposure) that women's underpants began to seem indispensable.[14] Once accepted, however, underpants began to become shorter and more luxurious. In 1885, the fashion writer Alice de Laincel extolled "Our *pantalons* of silk, clasped at the knee by a ribbon above a wreath of frothy lace"[15]

The petticoat worn closest to the body was usually plain, but outer petticoats (which were often glimpsed) were prettier and might be made of fine lawn or silk. Petticoats were usually white, but as early as 1858, the American magazine *Home Journal* published an article "The Red Petticoat Connubially Whip-Up Alive," which suggested that Queen Victoria had

worn a red petticoat "to reawaken the dormant conjugal susceptibility of Prince Albert."[16]

Colorful lingerie became increasingly popular in the later nineteenth century, although it was initially viewed with suspicion: "Color, in the secret clothing of women, is an entirely modern taste, deriving no doubt from the nervousness that torments our imagination, from the dulling of our sensations, from that unceasingly unsatisfied desire that causes us to suffer… and that we apply to all manifestations of our feverish life."[17] In the late 1870s, Henreiette Hauser's blue satin corset and blue silk stockings would have struck viewers of *Nana* as risqué and titillating; but within a decade, brightly colored corsets, petticoats, and stockings had become increasingly popular.

As the ideal of feminine beauty gradually changed, becoming less voluptuous, slimmer, and more girlish, fashion changed, too – and so did lingerie. The avant-garde couturier Paul Poiret later boasted that he had abolished the corset and introduced the brassiere.[18] This was an exaggeration, although he was certainly among the first designers to be associated with the "boneless corset" and the brassiere. As dresses became more form-fitting and body-exposing, lingerie followed suit. By 1908, *Vogue*'s correspondent in Paris wrote that "The petticoat is obsolete, pre-historic."[19] With the new Empire styles, there was hardly room under a dress for anything more than a little silk chemise or a "combination."

Modernism in fashion highlighted the "natural" and classically idealized body. In place of the more voluminous and restrictive styles of the Edwardian era, fashion became softer and sleeker. The flapper of the 1920s wore a simple frock over a brassiere, knickers, and silk stockings. By the 1930s, when body-conscious, bias-cut dresses dominated fashion, the modern one-piece slip (an invisible under-dress) developed, and knickers were replaced by even skimpier briefs. As Dorothy Parker once quipped, "Brevity is the soul of lingerie."[20]

At the end of the 1930s, the trend towards modernism in women's fashion gave way to a temporary vogue for historicizing, Belle Epoch-inspired fashion. Horst's famous 1939 photograph of a laced corset captures this neo-romantic style, which was soon interrupted by the outbreak of World War II. Historicizing fashion resumed when Dior's

"LES DESSOUS À LA MODE"
La Gazette du bon ton, November 1912, p. 31.
Fashion Institute of Technology/SUNY,
FIT Library Special Collections and FIT Archives,
New York, NY, USA.

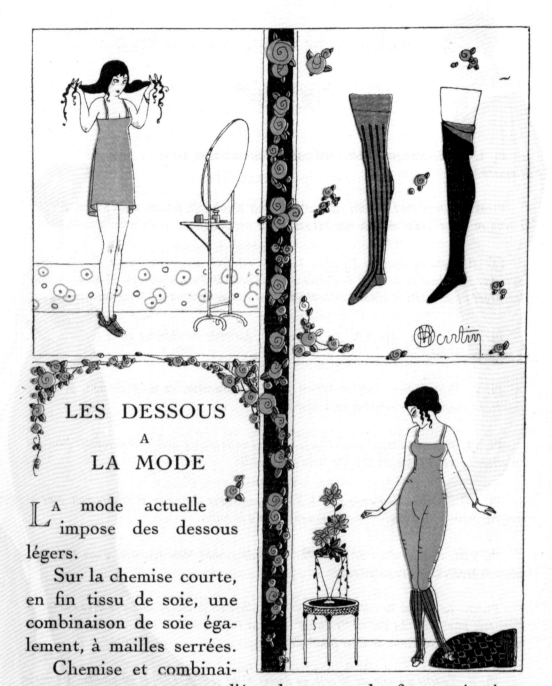

LES DESSOUS
A
LA MODE

LA mode actuelle
impose des dessous
légers.

Sur la chemise courte,
en fin tissu de soie, une
combinaison de soie éga-
lement, à mailles serrées.

Chemise et combinai-
sons ne sont retenues sur l'épaule que par des faveurs étroites.

C'est chez Lemaître, qu'il convient de choisir ces
frivolités. Il vend aussi les seuls bas de soie élégants.

New Look of 1947 brought back the hyper-feminine, hourglass figure, created by "waspy" girdles and layers of petticoats. Brassieres also became more structured during the 1940s and 1950s. Push-up cleavage and garter-belts were clichés of the era.

But by the 1960s, the pendulum had swung back to a girlish look with mini-skirts and colorful tights (no more garter-belts and stockings). "Fun" lingerie (now often referred to as "undies") included matching sets of bras and panties in playful patterns such as polka dots. Although 1960s lingerie utilized new materials, in many ways it recalled the youthful styles and sexually liberated ethos of the 1920s. A growing emphasis on the "natural" look led to developments such as the "no-bra bra," which was undetectable under even the tightest T-shirt.

With the rise of feminism, there was increasing criticism of what Angela Carter called "the 'fantasy courtesan' syndrome of the sexy exec," whereby working women sought to "regain the femininity they have lost behind the office desk by parading about like a *grande horizontale* from early Colette in the privacy of their flats, even if there is nobody there to see."[21] Although most lingerie advertising utilized soft-focus imagery of a single woman lounging in privacy, a few photographers, such as Guy Bourdin, pioneered a more hard-edge style that evoked police-style flash photographs of women in brothels.

Throughout all the vicissitudes of fashionable lingerie from the 1980s to the present – from the Wonderbra to the thong – one thing remained constant: lingerie was perceived as an exceptionally erotic category of women's fashion. Perhaps the most notable new development was the appearance of underwear-as-outerwear, a deliberately transgressive style, which emerged from the punk movement and which included a revival of the corset. The first fashion designer to promote the look was Vivienne Westwood, herself a punk, to be followed by Jean Paul Gaultier (and Madonna), John Galliano at Christian Dior, and Lee Alexander McQueen. First corsets and bras were worn as outerwear, then slips became dresses. Westwood's son, Joseph Corre, would go on to found the hyper-sexy lingerie company, Agent Provocateur.

But the future lay not only with the luxurious and the erotic, as athletic, androgynous underwear has increasingly merged with street wear. During the golden age of lingerie, women's underwear had moved simultaneously toward the hyper-feminine and towards the sporty and practical. A century later, the athletic would be redefined as another style of eroticism. The ubiquitous T-shirt, for example, originated early in the twentieth century as a man's undershirt before becoming outerwear for both sexes. With the expansion of sexual liberation and human rights to include gay liberation,

even men's underwear began to be openly perceived and promoted as sexually attractive. Bruce Weber's photographs of god-like men in Calvin Klein underpants towered over the urban landscape and, later, Steven Meisel photographed both Marky Mark and Kate Moss in Klein's androgynous underwear. In addition to mannish boxer shorts and briefs, women have also adopted sports bras (which go back, historically, to the *strophium* of the Roman Empire), camisoles (which are derived from the nineteenth-century corset cover), and the dancer's leotard.

It may not always be hidden underneath any more, but lingerie remains, even today, a second skin.

NOTES /

1 Anatole France, quoted in Francine Pacteau, *The Symptom of Beauty* (London: Reaktion Books, 1994), 151.
2 Émile Zola, *Au Bonheur des dames* [originally published in 1883] (Paris: Le Livre de Poche, n.d.), 478.
3 Manet, quoted in Beth Archer Brombert, *Edouard Manet: Rebel in a Frock Coat* (Little Brown, 1996), 384.
4 *The Ladies Realm* (April 1903): 767.
5 Mrs. Eric Pritchard, *The Cult of Chiffon* (London: Grant Richards, 1902), 16.
6 Octave Uzanne, *Fashion in Paris, 1797–1897* (London: Heinemann, 1898), 172.
7 Octave Uzanne, *L'Art et les Artifices de la Beauté* (Paris: Félix Juven, 1902), 212–14.
8 Joris-Karl Huysman, quoted in Hollis Clayson, *Painted Love: Prostitution in French Art of the Impressionist Era* (New Haven and London: Yale University Press, 1991), 78.
9 Comtesse de Tramar, *Le Bréviare de la femme: pratiques secrets de la beauté* (Paris: Havard, 1903), 169–71.
10 Pritchard, *Cult of Chiffon*, 20.
11 Baronne d'Orchamps, *Tous les Secrets de la femme* (Paris: Bibliothèque des Auteurs Moderns, 1907), 78–79.
12 *Lady's Realm* (December 1902), 291.
13 Dr. Daumas, "Hygiène et medicine," quoted in Philippe Perrot, *Fashioning the Bourgeoisie: A History of Clothing in the Nineteenth Century* (Princeton: Princeton University Press, 1994), 150.
14 Perrot, *Fashioning the Bourgeoisie*, 146–48.
15 Violette [Alice de Laincel], *L'Art de la toilette chez la femme: Bréviare de la vie* élégante (Paris, 1885), 41.
16 *Home Journal* (13 February 1858), quoted in William Leach, *True Love and Perfect Union* (London and Henley: Routledge and Kegan Paul, 1981), 219.
17 Pierre de Lano, *L'Amour à Paris sous le Second Empire* (Paris, 1896), quoted in Perrot, *Fashioning the Bourgeoisie*, 160.
18 *The Queen* (March 1911), quoted in Nora Waugh, *Corsets and Crinolines* (London: B. T. Batsford, 1954), 112.
19 Paul Poiret, *King of Fashion: The Autobiography of Paul Poiret* (London: J. B. Lippincott, 1931), 76–77.
20 Dorothy Parker, quoted in Caroline Cox, *Lingerie: A Lexicon of Style* (New York: St. Martin's Press, 2000), 126.
21 Angela Carter, "The Bridled Sweeties," quoted in Cox, *Lingerie*, 135.

PEIGNOIR À COULISSE /

From *Galeries des modes et costumes français*
(reprint, Paris: É. Lévy, 1912).
Fashion Institute of Technology/SUNY,
FIT Library Special Collections
and FIT Archives, New York, NY, USA.

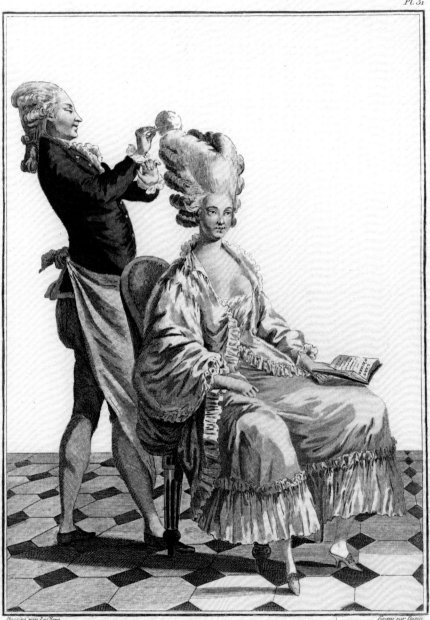

Pl. 31

Dessiné par LeClerc *Gravé par Dupin*

Jeune Dame se faisant coëffer à neuf; elle est en peignoir et sa juppe de gaze d'un jaune très tendre,
Le Coëffeur en veste rouge un peu poudrée, culotte noire et bas de soie gris.

QUILTED PETTICOAT / *SILK SATIN, ca.1765, ENGLAND*

Quilted petticoats of the mid- to late eighteenth century functioned as both underclothing and outer garments. Some women's gowns were made with skirts that opened in front, revealing petticoats that complemented dress fabrics. Different petticoats could be mixed and matched with the same gown, changing the look of the ensemble without necessitating the purchase of an entirely new dress.[1]

Such petticoats were typically made with a layer of woolen batting between the outer fabric and the lining material. While this gave more depth to the quilting technique, it also made the petticoat suitable for cold weather. As the sewing machine was not invented until the mid-nineteenth century, all of the elaborate quilting was completed by hand.

[1] Linda Baumgarten, *Eighteenth-Century Clothing at Williamsburg* (Williamsburg, Va.: The Colonial Williamsburg Foundation, 2004), 20.

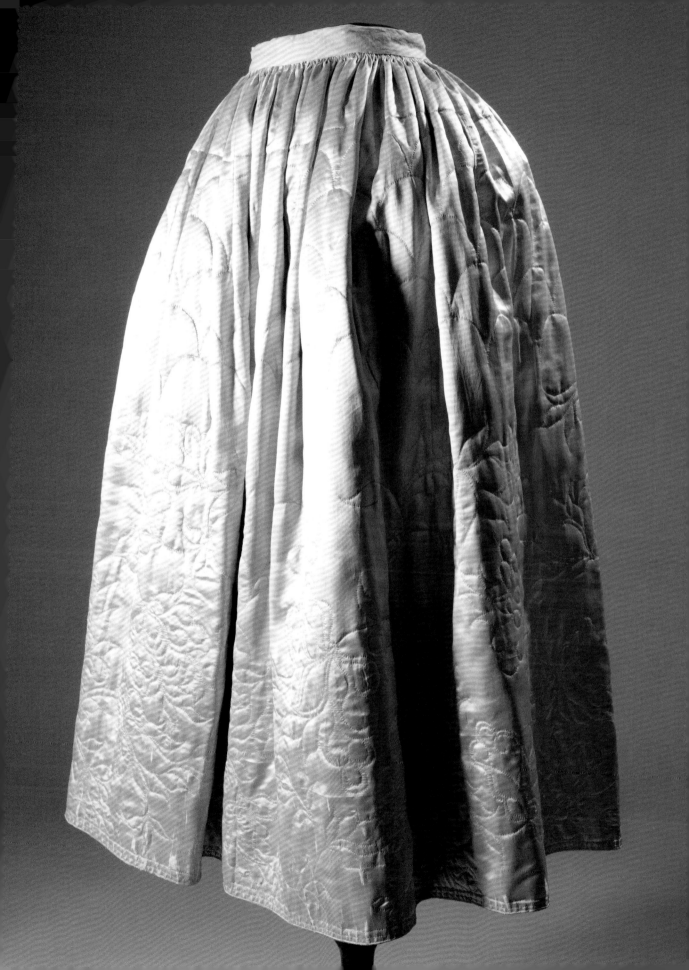

CORPS DE BALEINE À LA MODE / *1778*

From *Galeries des modes et costumes français*
(reprint, Paris: É. Lévy, 1912).
Fashion Institute of Technology/SUNY,
FIT Library Special Collections
and FIT Archives, New York, NY, USA.

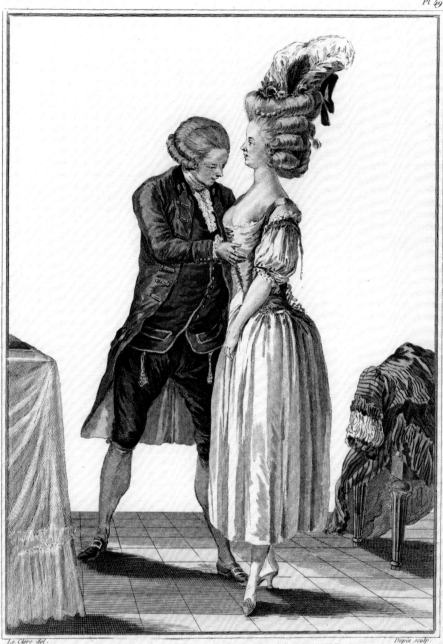

Pl. 49

TAILLEUR COSTUMIER ESSAYANT UN COR A LA MODE.

Le Clerc del. Dupin sculp.

Il est vêtu d'un habit noisette a collet noir de velours, deux boutonieres d'or, les boutons et boutonieres de l'Habit de même, une veste de tricot cerise avec une tresse d'or, culotte de velours noir, et bas de soie gris : la jeune personne n'a qu'un simple jupon et des bas blancs, et son cor couvert de batiste teinte en jaune.

CORSET (STAYS) / *SILK, SILK RIBBON, WHALEBONE ca.1770, POSSIBLY EUROPE*

Stays were obligatory for the "strait-laced" woman of the eighteenth century. An integral component of their construction was the busk, a piece of whalebone (or similar material) that was inserted between layers of fabric in the center front. Busks kept the stays – and by extension, the wearer's body – straight and erect. Other, narrower pieces of whalebone further maintained the desired inverted conical shape. Stays also enhanced the breasts by pushing them up and together.

Although stays were worn as garments of propriety, they also held an erotic allure. In France, the toilette *– a semipublic ritual of dressing and undressing – included the important subtheme of putting on a corset.[1] These decorative stays may have been worn as part of an at-home ensemble, as indicated by the attached sleeves.[2]*

[1] Valerie Steele, *The Corset: A Cultural History* (New Haven and London: Yale University Press, 2001), 18.

[2] Kyoto Costume Institute Digital Archives, accessed January 21, 2014, http://www.kci.or.jp/archives/digital_archives/ detail_1_e.html.

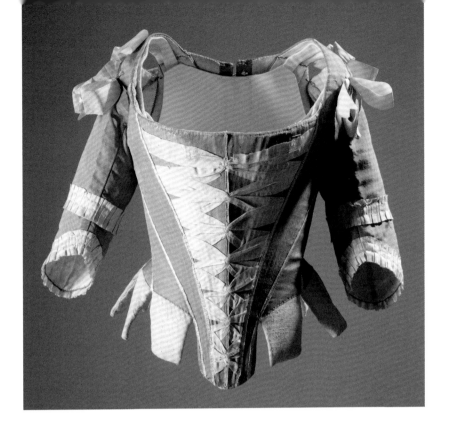

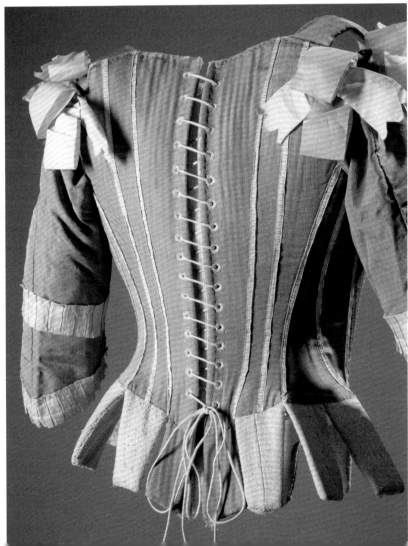

SIGMUND FREUDEBERG / *'LA TOILETTE,'* 1774

From Ernest Leoty, *Le Corset à travers les âges*
(Paris: P. Ollendorff, 1893), 61.
Fashion Institute of Technology/SUNY,
FIT Library Special Collections
and FIT Archives, New York, NY, USA.

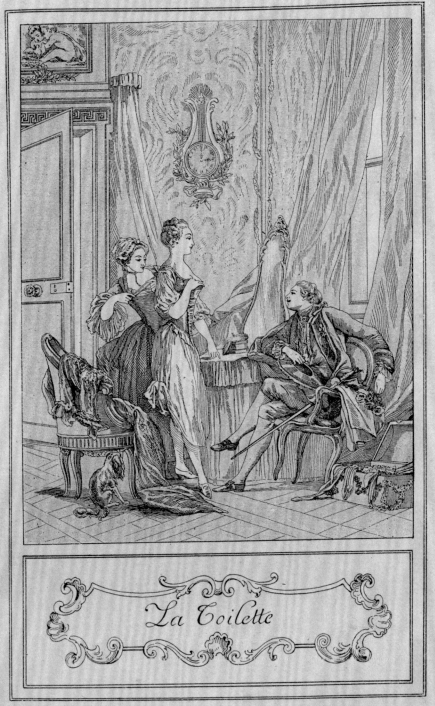

La Toilette

Pl. VI. Freudeberg (1745–1801).

CORSET / *COTTON SATEEN, ca.1815, ENGLAND*

A fashion article in 1811 described "a short corset, fitted exactly to the natural shape, without permitting any attempt to push the form out of its place,"[1] as the ideal style to wear beneath the fashionably high-waisted, "Grecian" gowns. Emphasis on the bust is created in this example by contoured cups that lift the breasts, as well as a busk that was inserted into a center front casing to separate and define them. The corset is otherwise softly constructed from two layers of fabric.

Detailed topstitching and trapunto techniques were common to corsets from this era. Many corsets made from 1800 to about 1870 were made from white fabrics, which were associated with chastity,[2] but black, grey, and brown corsets were also prevalent.

[1] "Miscellaneous Selections from English Papers: Fashions," *The Balance and State Journal* (November 5, 1811): 353.

[2] Valerie Steele, *The Corset: A Cultural History* (New Haven and London: Yale University Press, 2001), 39.

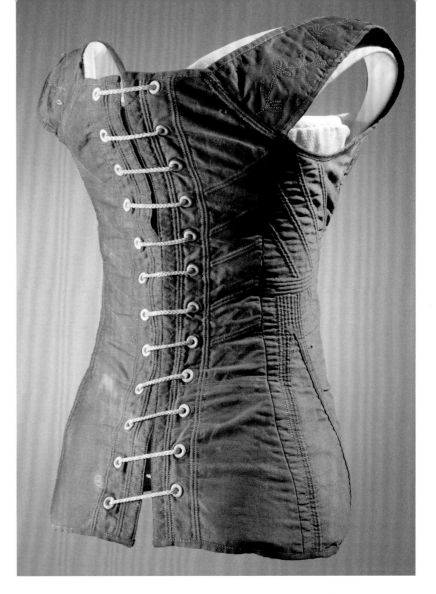

MLLE FORMENTIN / *'L'UTILE MARCHANDE DE CORSETS,' 1830*

After Charles Philipon
From *Le Corset dans l'art et les moeurs du XIIIe au XXe*
(Paris: F. Libron, 1933).
Fashion Institute of Technology/SUNY,
FIT Library Special Collections
and FIT Archives, New York, NY, USA.

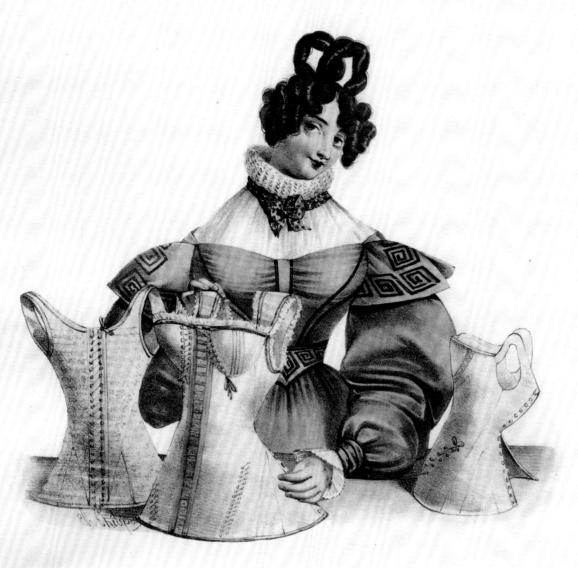

L'utile. M. de de Corsets

(Paris)

N.º 37

Le dessin chez F. Saut, rue des Sts. Pères 11. Imp. Lith. de M.lle Formentin, rue des Sts. Pères 11.

Published by Charles Tilt, 86. fleet street. London.

DRESSING GOWN / *COTTON AND LACE, ca.1840, USA*

As their name implies, dressing gowns were specialized garments worn before a woman dressed. Rules of propriety dictated that their use be confined to the privacy of a woman's bedroom or dressing room. Many existing dressing gowns from the early to mid-nineteenth century were modestly designed, and were made from plain white cotton or linen fabric. Some were subtly trimmed with white lace.

Although few people were meant to see dressing gowns, they usually followed the fashionable silhouette. Several of the characteristics of this example, such as the full sleeves and smocked, pointed waist, resemble those seen on dresses from the early 1840s. Its button-front closure and soft, tie belt allowed for ease of wear, and verify its status as an at-home garment.

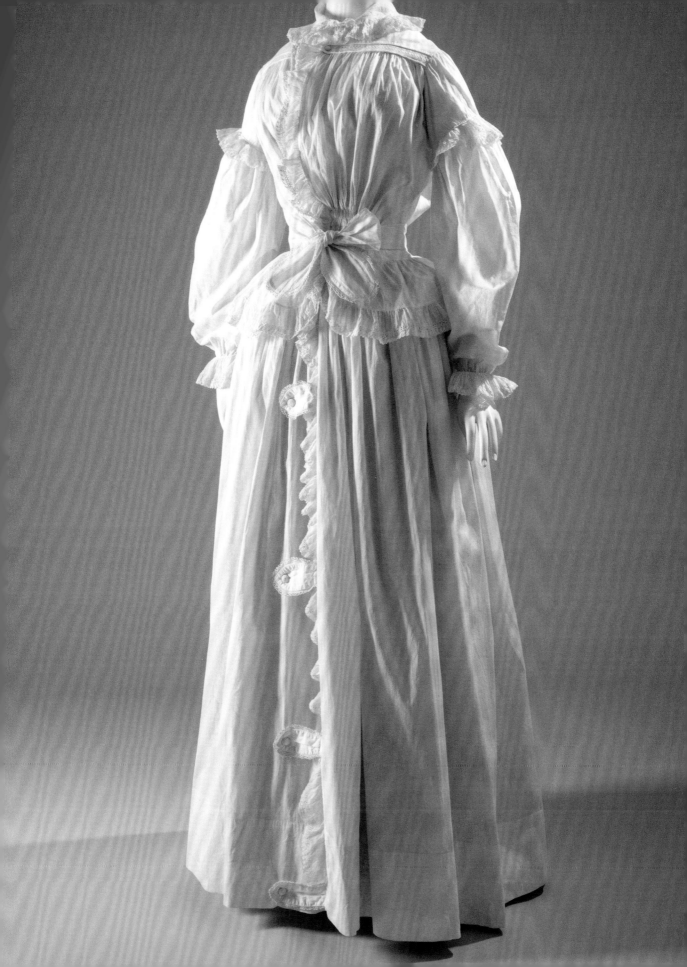

PEIGNOIR / *EMBROIDERED WOOL, ca.1878, USA*

Peignoirs (taken from the French peigner, to comb) were alternately known as combing dresses, wrappers, and morning robes. While it is certain that the peignoir functioned as an intimate, at-home garment, the way it was worn is a subject of debate. An 1874 article detailing the virtues of the peignoir despaired that while "Frenchwomen do not think it necessary to put on the saddles and bridles of fashion when they rise … our fair Americans have a bad habit of attiring themselves in corsets and other appurtenances of fashion in the morning." The author went on to describe the peignoir's intended function as a release "from the mortal coil of clothes."[1]

This peignoir loosely follows the shape of the fashionable silhouette, but it was likely worn without a corset. Its standing collar, floral embroidery, and tasseled "frog" closures signify Chinese influence on western dress. While earlier peignoirs often emphasized practicality over prettiness, this design exemplifies the shift toward more lavish intimate apparel during the late nineteenth century.

[1] "Etc.," *Overland Monthly and Out West Magazine* (November 1874): 479.

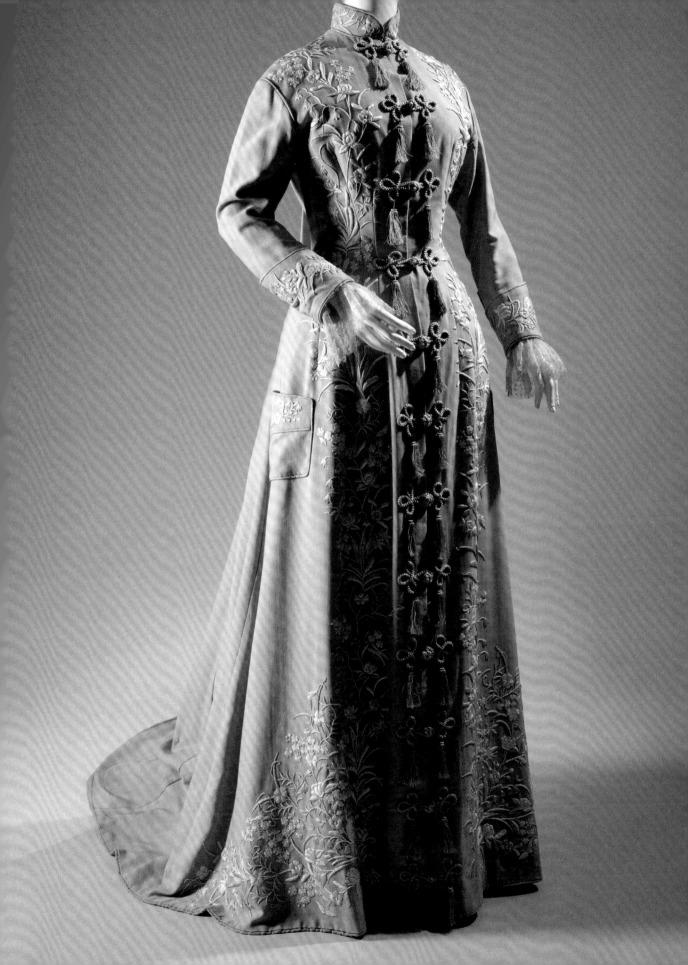

CORSET / *WOOL, SILK, STEEL, WHALEBONE, ca.1880, POSSIBLY FRANCE*

BUSTLE / *PRINTED COTTON, STEEL, ca.1880, USA*

The bustle appeared late in the 1860s.[1] It took many forms over the next twenty years, but all bustles were designed to emphasize the posterior. They created a marked contrast to slim, corseted waists covered in tightly fitted bodices.[2] Skirts that were heavily gathered, pleated, and embellished in back further enhanced the bustle silhouette.

Some smaller versions of the bustle were made from wire mesh, short hoops, or cushions that were fastened to the body with a buckled waist tape. The more extreme bustle styles, such as those of the early 1880s, were often more elaborately structured. This example – a hybrid of a bustle and a petticoat – was sometimes referred to as a "crinolette." Although the crinolette maintained the desired skirt shape, it proved somewhat difficult to wear. One magazine from the period despaired that it was prone to wobbling when the wearer walked, and recommended that women instead have their skirts made with built-in, horsehair bustles.[3]

[1] Casey Finch, "Hooked and Buttoned Together: Victorian Underwear and Representations of the Female Body," *Victorian Studies* 34 (Spring 1991): 346.

[2] "Ladies' Department: Fashion Chat," *Saturday Evening Post* (September 9, 1882): 16.

[3] Ibid.

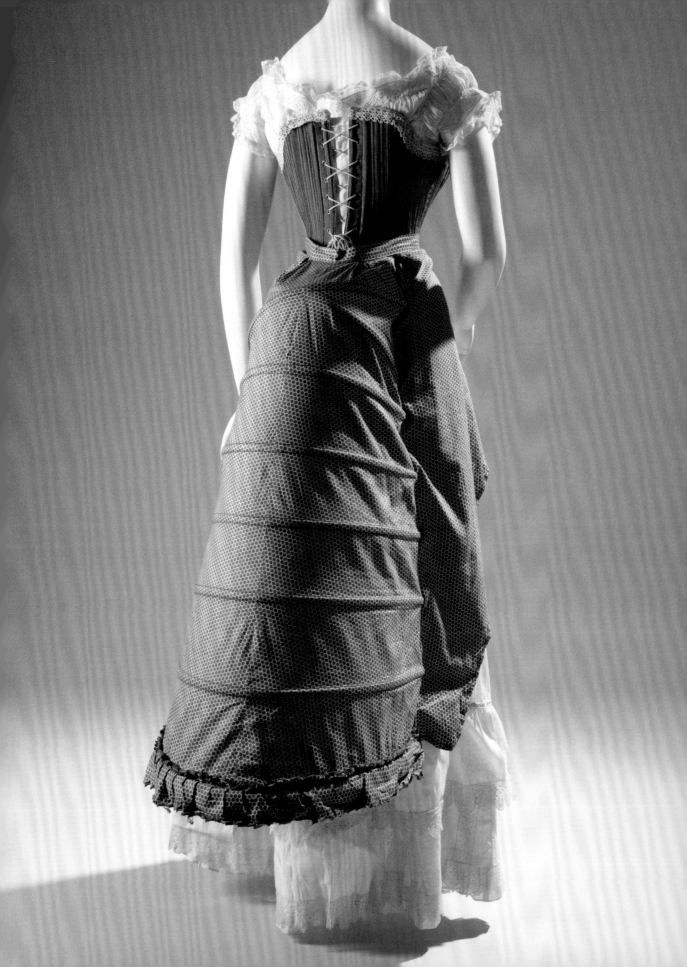

WARNER BROS. CORSET / *SILK, SATIN, CORALINE, ca.1889, USA*

"The last remains of feminine modesty sunk out of sight, drowned by the prevalent mania for elaborate underclothing,"[1] wrote the journalist Octave Uzane in his book Fashions in Paris *(1898). Surely the acceptance of colorful corsets helped to fuel Uzane's statement, as such foundation undergarments had formerly been associated with actresses and courtesans.*

In order to create the exaggeratedly feminine, curvaceous silhouette that dominated the second half of the nineteenth century, corsets were rigidly shaped with whalebone or steel. Warner Bros., the manufacturer of this corset, specialized in using Coraline, a plant-based stiffening material. Coraline was touted as a more flexible and less "torturous" alternative to other corset shapers—meaning that this seductive, raspberry silk example was likely marketed as a "healthy" corset.[2]

[1] Octave Uzanne, *Fashions in Paris* (London: William Heinemann, 1898), 163.

[2] Warner Bros., *Coraline Corsets* (Bridgeport, Conn.: Warner Bros., 187[?]), Internet Archive, accessed March 24, 2014, https://archive.org/stream/warnerbroscorali00warn#page/n0/mode/2up.

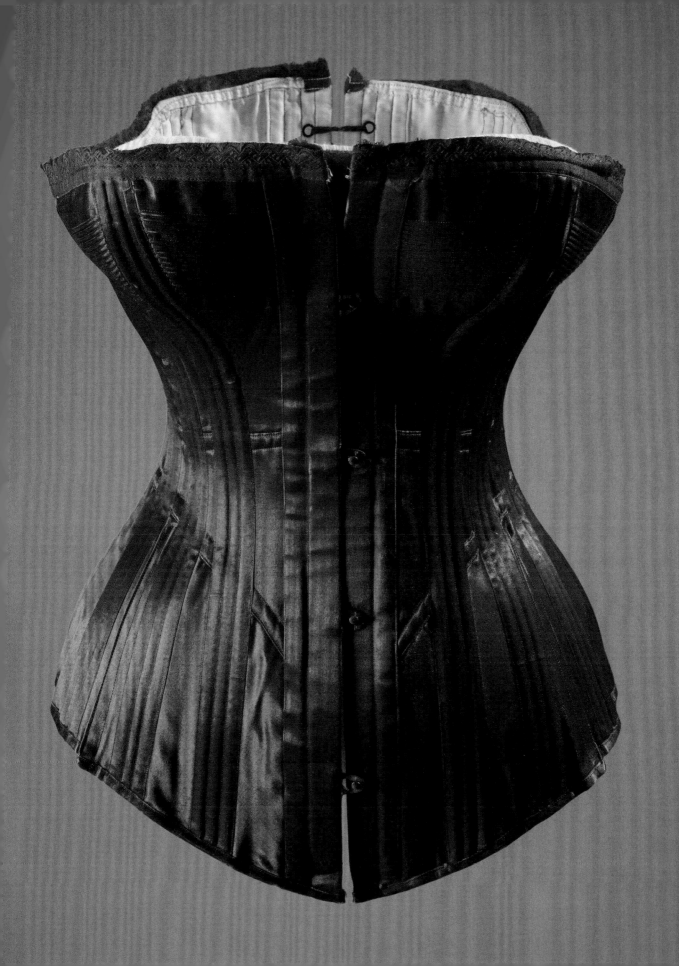

CORSET MODERNE / *ca.1893*

From Ernest Leoty, *Le Corset à travers les âges*
(Paris: P. Ollendorff, 1893), 103.
Fashion Institute of Technology/SUNY,
FIT Library Special Collections
and FIT Archives, New York, NY, USA

PLANCHE XVII

Corset moderne.

M. A. SPENCER CORSET / *SILK, ca.1898, USA*

PETTICOAT / *POLISHED COTTON, ca.1890, USA*

Black undergarments stood in stark contrast to the prevailing fashion for "pure" white styles during the nineteenth century. While widows often wore black corsets as part of their mourning costumes, black was also gaining prominence as a fashion color, and it was advisable that women wear dark underwear under any dress made from black fabric.[1]

The fashionable woman wore layers of petticoats, many of which were made from plain white fabrics. Brightly colored petticoats began to appear in the 1860s, as synthetic dyes became widespread.[2] *These vivid, decorative styles were often worn over more subdued examples, since the topmost petticoat might be glimpsed at the hem of the wearer's skirt as she moved.*[3]

[1] Jill Fields, *An Intimate Affair: Women, Lingerie and Sexuality* (Berkeley: University of California Press, 2007), 133.

[2] Elizabeth Ewing, *Dress and Undress: A History of Women's Underwear* (London: B. T. Batsford, Ltd.: 1978), 76.

[3] Valerie Steele, *Fashion and Eroticism: Ideals of Feminine Beauty from the Victorian Era to the Jazz Age* (New York and Oxford: Oxford University Press, 1985), 194.

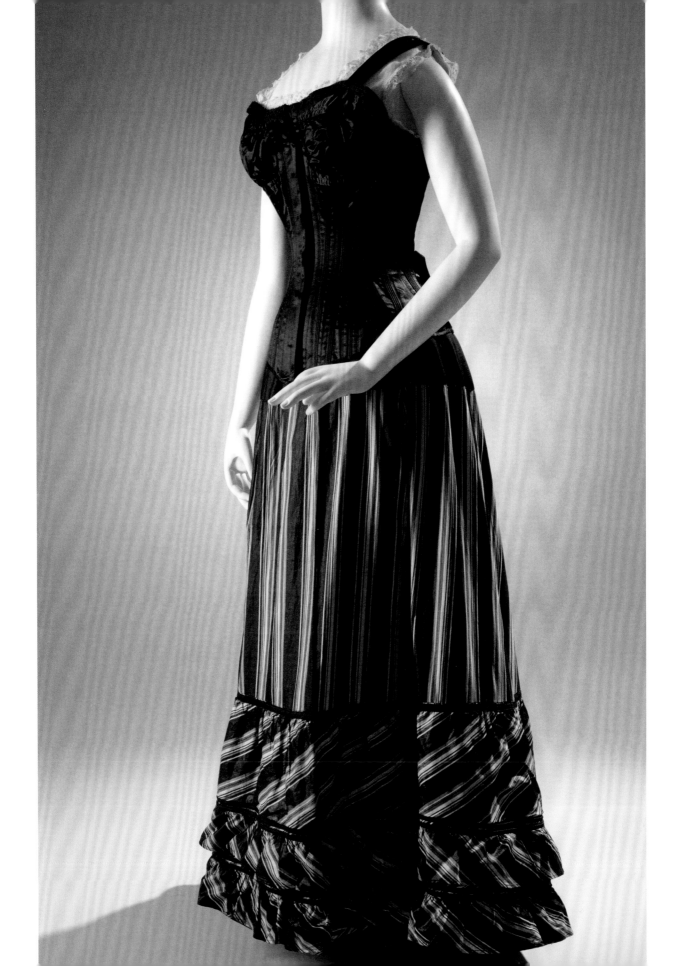

STOCKINGS / *SILK, ca.1900, FRANCE*

*Before hemlines began to rise in the 1910s, women's stockings
were often hidden beneath long skirts. This allowed them
to be private mediums for whimsy and self-expression. Late
nineteenth-century designs often featured elements such as
patterning, decorative insets, and embroidered motifs over the
feet and calves. From the 1860s through the 1890s, red stockings
were especially fashionable.[1] This brightly hued pair is intricately
embroidered with a playing card motif – the Jack of Hearts –
perhaps indicating that they were a gift from a loved one.*

[1] Jeremy Farrell, *Socks and Stockings* (London: B. T. Batsford,
 1992), 60.

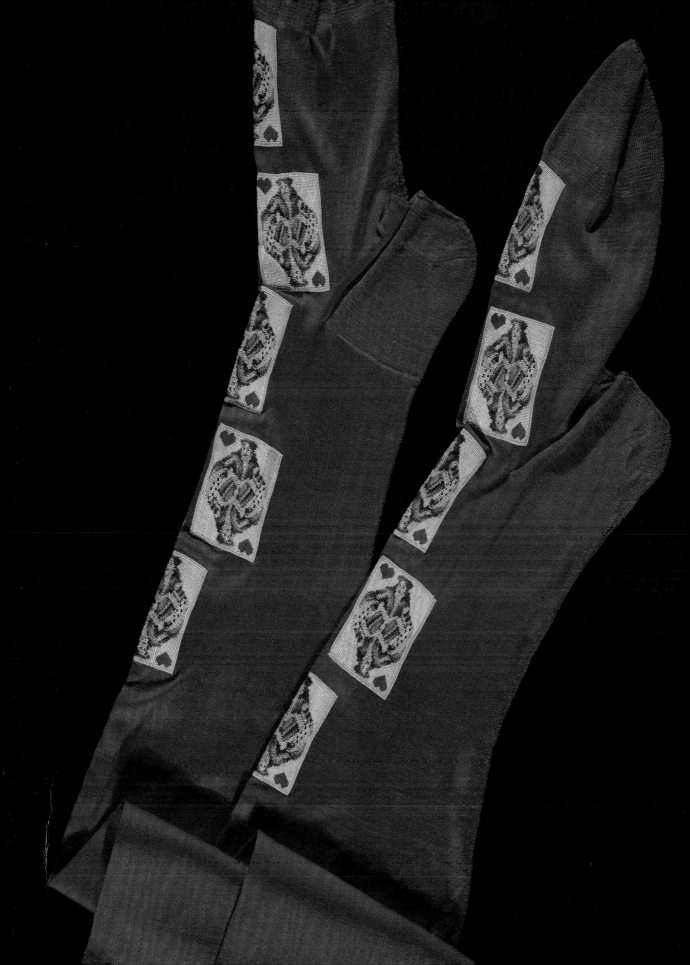

FERNANDE BUREL TEA GOWN / *CARNATION-PRINTED SILK CHIFFON, SILK, LACE, ca.1900, FRANCE*

A 1905 article in Harper's Bazaar *underscored that tea gowns played "a most important part in the modern outfit, and, indeed, so excessively dainty and charming are they, it can be scarcely wondered that women consider that a good proportion of the dress allowance must be allotted to their purchase."[1] Developed from the more demure style of the dressing gown, the tea gown was a loose-fitting garment that did not require a corset. Tea gowns served strictly as at-home garments in the early twentieth century, but because they could be worn to receive visitors, many were crafted from opulent materials.*

Fernande Burel, the upscale French designer who made this example, also specialized in making delicate shirtwaist blouses and lingerie dresses. As one of Burel's blouses could cost upwards of $65 during the early twentieth century – over $500 today[2] – one can only imagine the expense of this lavishly trimmed, chiffon tea gown. It was worn by Lulu Glaser, a prominent American actress and singer.

[1] "Negligees and House Gowns," *Harper's Bazaar* (October 1905): 910.

[2] US Inflation Calculator, accessed March 7, 2014, www.usinflationcalculator.com.

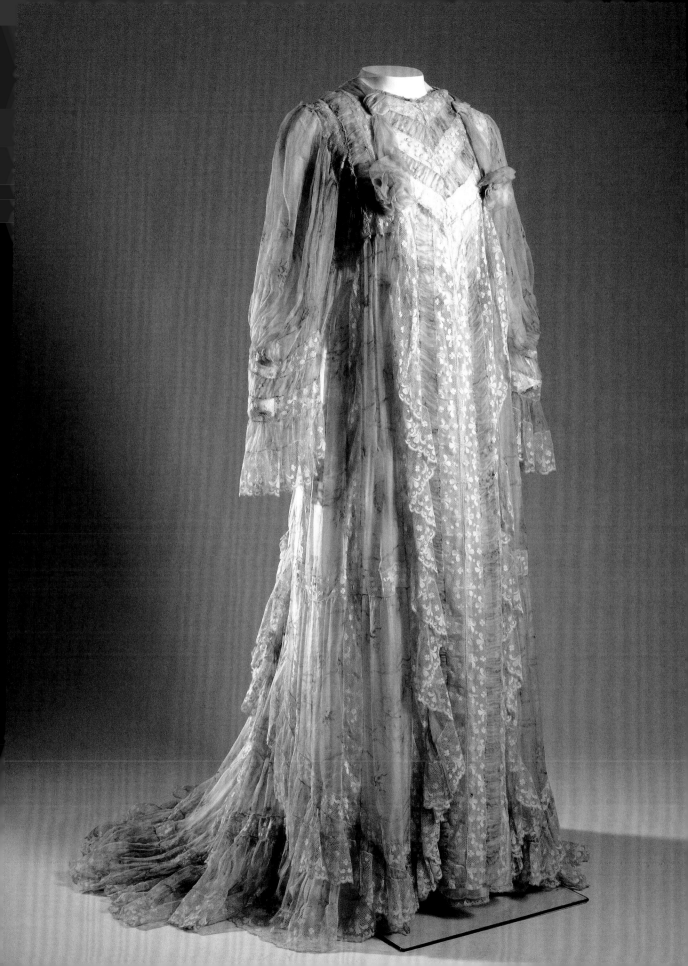

COMBINATION / *COTTON EYELET LACE, SILK RIBBON, ca.1900, USA*

While at-home attire was becoming more elaborate during the early part of the twentieth century, women's underclothes were being increasingly streamlined. One essential type of lingerie was the combination, which joined a camisole and drawers into a single garment. Although combinations were available as early as the 1870s,[1] an increased desire to eliminate layers of undergarments coincided with the slimmer silhouette of the Edwardian era.

Many lingerie styles of the early twentieth century were still made from traditional white linen or cotton, in spite of the acceptance of more colorful undergarments. The design of this combination is a mix of old and new ideas: the choice of white fabric was conventional, while its laciness corresponded to the delicacy typical of lingerie from this period.

[1] Jill Fields, *An Intimate Affair: Women, Lingerie, and Sexuality* (Berkeley: University of California Press, 2007), 41.

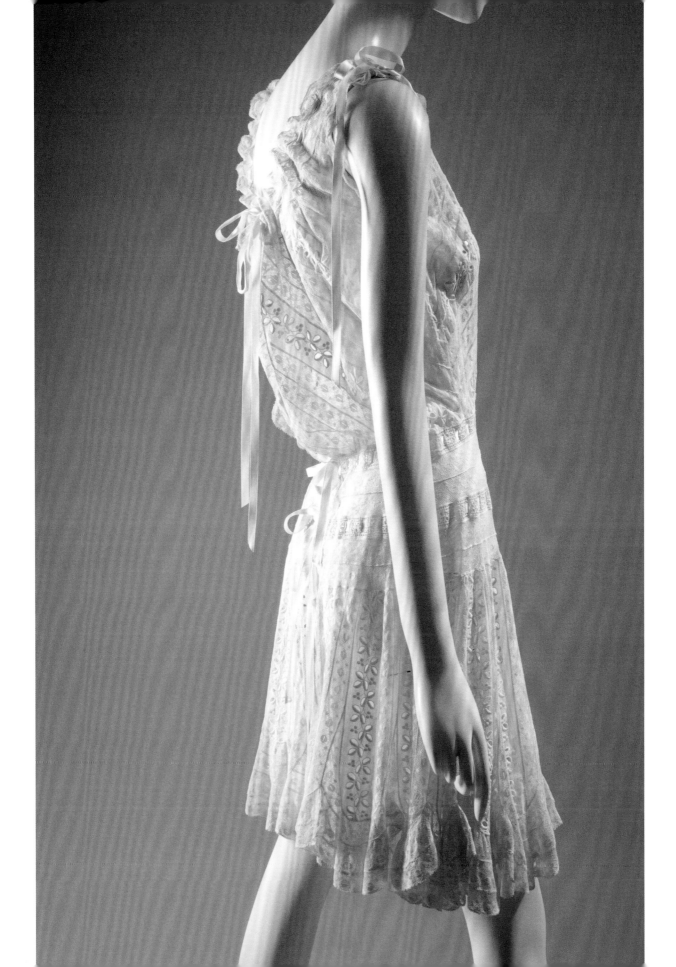

CORSET / *FLORAL BROCADED SILK, SILK RIBBON, ELASTIC, ca.1905, ENGLAND*

CHEMISE / *WHITE COTTON, SILK RIBBON, ca.1905, USA*

The new, straight-front corset style of the early twentieth century rested low on the bosom, and began to extend over the hips. The resulting shape was an "S curve" that pushed the breasts forward, pressed in the stomach, and arched the back. Although this corset shape appeared sinuous and alluring, it was also highly constricting. Debates regarding the perils of corsetry intensified during this time period.[1]

The fashionable woman was advised to take as much time and care selecting her lingerie as she did for her outer garments. This corset is worn over an ornate, princess-seamed chemise (or slip), a design that eliminated layers of petticoats to create an appealingly slender silhouette. Colorful ribbon embellishments were considered particularly dainty,[2] but they could also serve a function, such as adjusting fit at the neckline.

[1] Jill Fields, "Fighting the Corsetless Evil: Shaping Corset and Culture, 1900–1930," *Journal of Social History* 33 (Winter 1999): 355.

[2] "Dainty Lingerie," *Pictorial Review* (February 1900): 11.

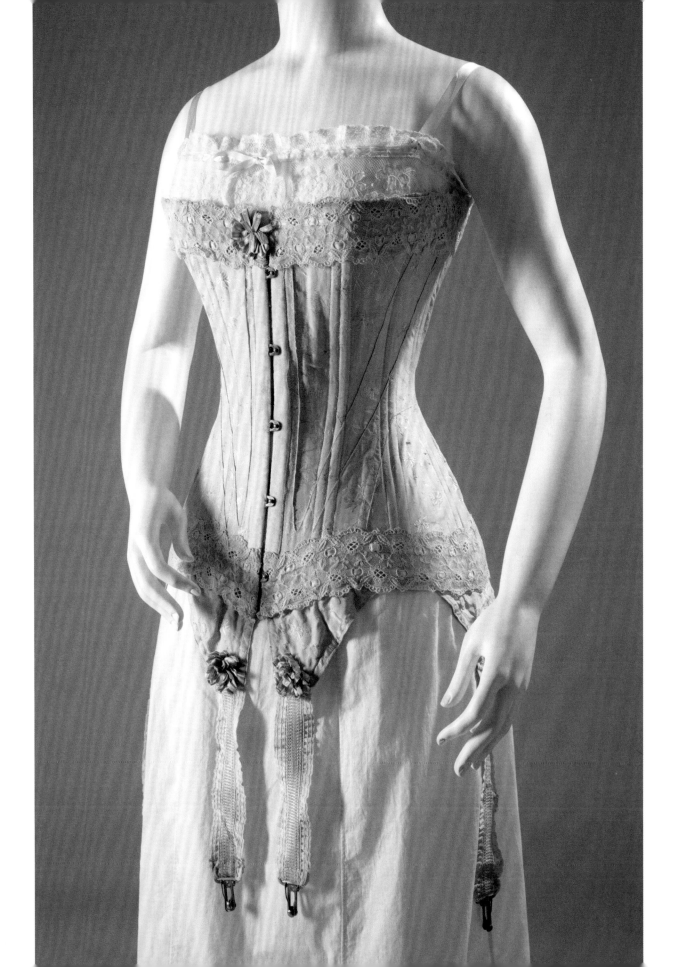

IL EST NÉ LE DIVIN CORSET / *FABIANO, ca.1905*

From *Le Corset Americaín W.B. à ses gracieuses clients*, front page
Fashion Institute of Technology/SUNY,
FIT Library Special Collections and
FIT Archives, New York, NY, USA

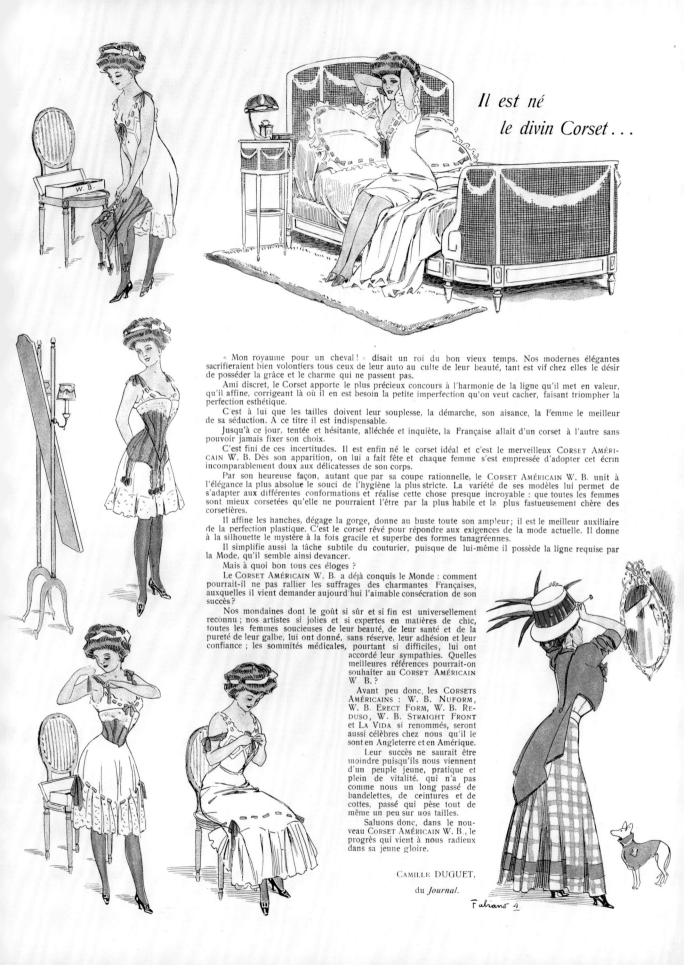

Il est né
le divin Corset...

« Mon royaume pour un cheval! » disait un roi du bon vieux temps. Nos modernes élégantes sacrifieraient bien volontiers tous ceux de leur auto au culte de leur beauté, tant est vif chez elles le désir de posséder la grâce et le charme qui ne passent pas.

Ami discret, le Corset apporte le plus précieux concours à l'harmonie de la ligne qu'il met en valeur, qu'il affine, corrigeant là où il en est besoin la petite imperfection qu'on veut cacher, faisant triompher la perfection esthétique.

C'est à lui que les tailles doivent leur souplesse, la démarche, son aisance, la Femme le meilleur de sa séduction. A ce titre il est indispensable.

Jusqu'à ce jour, tentée et hésitante, alléchée et inquiète, la Française allait d'un corset à l'autre sans pouvoir jamais fixer son choix.

C'est fini de ces incertitudes. Il est enfin né le corset idéal et c'est le merveilleux CORSET AMÉRICAIN W. B. Dès son apparition, on lui a fait fête et chaque femme s'est empressée d'adopter cet écrin incomparablement doux aux délicatesses de son corps.

Par son heureuse façon, autant que par sa coupe rationnelle, le CORSET AMÉRICAIN W. B. unit à l'élégance la plus absolue le souci de l'hygiène la plus stricte. La variété de ses modèles lui permet de s'adapter aux différentes conformations et réalise cette chose presque incroyable : que toutes les femmes sont mieux corsetées qu'elle ne pourraient l'être par la plus habile et la plus fastueusement chère des corsetières.

Il affine les hanches, dégage la gorge, donne au buste toute son ampleur; il est le meilleur auxiliaire de la perfection plastique. C'est le corset rêvé pour répondre aux exigences de la mode actuelle. Il donne à la silhouette le mystère à la fois gracile et superbe des formes tanagréennes.

Il simplifie aussi la tâche subtile du couturier, puisque de lui-même il possède la ligne requise par la Mode, qu'il semble ainsi devancer.

Mais à quoi bon tous ces éloges ?

Le CORSET AMÉRICAIN W. B. a déjà conquis le Monde : comment pourrait-il ne pas rallier les suffrages des charmantes Françaises, auxquelles il vient demander aujourd'hui l'aimable consécration de son succès ?

Nos mondaines dont le goût si sûr et si fin est universellement reconnu ; nos artistes si jolies et si expertes en matières de chic, toutes les femmes soucieuses de leur beauté, de leur santé et de la pureté de leur galbe, lui ont donné, sans réserve, leur adhésion et leur confiance ; les sommités médicales, pourtant si difficiles, lui ont accordé leur sympathies. Quelles meilleures références pourrait-on souhaiter au CORSET AMÉRICAIN W. B. ?

Avant peu donc, les CORSETS AMÉRICAINS : W. B. NUFORM, W. B. ERECT FORM, W. B. REDUSO, W. B. STRAIGHT FRONT et LA VIDA si renommés, seront aussi célèbres chez nous qu'il le sont en Angleterre et en Amérique.

Leur succès ne saurait être moindre puisqu'ils nous viennent d'un peuple jeune, pratique et plein de vitalité, qui n'a pas comme nous un long passé de bandelettes, de ceintures et de cottes, passé qui pèse tout de même un peu sur nos tailles.

Saluons donc, dans le nouveau CORSET AMÉRICAIN W. B., le progrès qui vient à nous radieux dans sa jeune gloire.

CAMILLE DUGUET,
du *Journal*.

BUST SUPPORTER / *NATURAL COTTON, LINEN, COTTON TRIM, ca.1905, FRANCE*

Designs for bust supporters and proto-brassieres were first patented late in the nineteenth century. By the early 1900s, they had proliferated. These garments were able to lift and enhance the breasts in ways that were not possible with traditional corsetry.[1] While bust supporters took a variety of forms, this heavily boned example would have been worn to create the fashionable "monobosom" silhouette of the early twentieth century. It was likely paired with a low-topped corset that fit under the breasts and extended over the hips. Brassieres eclipsed bust supporters as fashion continued to evolve, and the "bra" was firmly established as a woman's essential underpinning by 1917.[2]

[1] Jane Farrell-Beck and Colleen Gau, *Uplift: The Bra in America* (Philadelphia: University of Pennsylvania Press, 2002), xii.

[2] Ibid., 21.

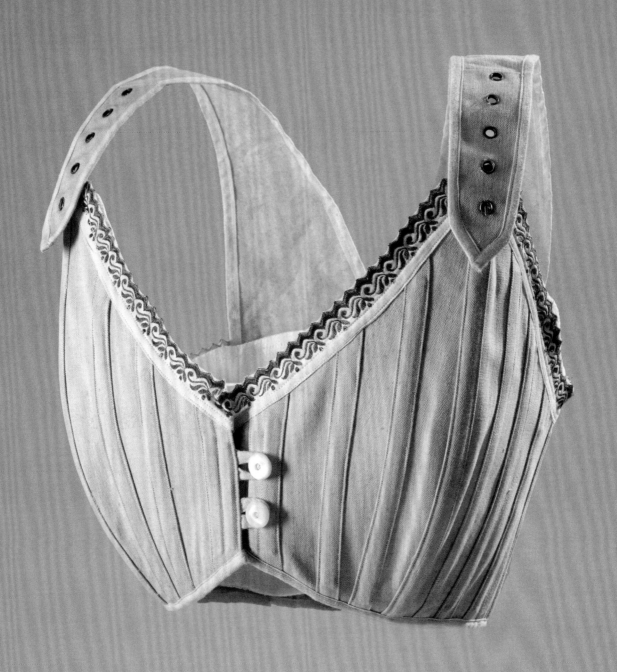

NIGHTGOWN / *COTTON, BOBBIN LACE, SILK RIBBON, 1907, USA*

This delicate nightgown was made by a young bride's mother for a trousseau. While many early twentieth-century nightgowns were beautifully designed, this example is particularly alluring. Its sleeves are fashioned from bands of lace, loosely held together by satin bows, and another bow draws attention to the gown's low-cut back. The handmade lace and fine, gauzy cotton further underscore the nightgown's seductive qualities.

A bridal trousseau consisted of many items – from house wares and linens to outerwear – but lingerie was an especially crucial component. If a bride made her selections well, she would not need to purchase new underclothes for several years.[1] By the early twentieth century, a trousseau could include both handmade and ready-made garments.[2]

During the nineteenth century, trousseaux were often put on view for female family members and friends. An extensive trousseau indicated a family's wealth and status. Such exhibitions were less common by the following century, and trousseaux disappeared almost entirely after World War II.[3]

[1] L. B. Walford, "The Lace Camisole," *Century Illustrated Magazine* (December 1900): 178.

[2] Ibid.

[3] Muriel Barbier and Shazia Boucher, *The Story of Women's Underwear* (New York: Parkstone International, 2010), 94.

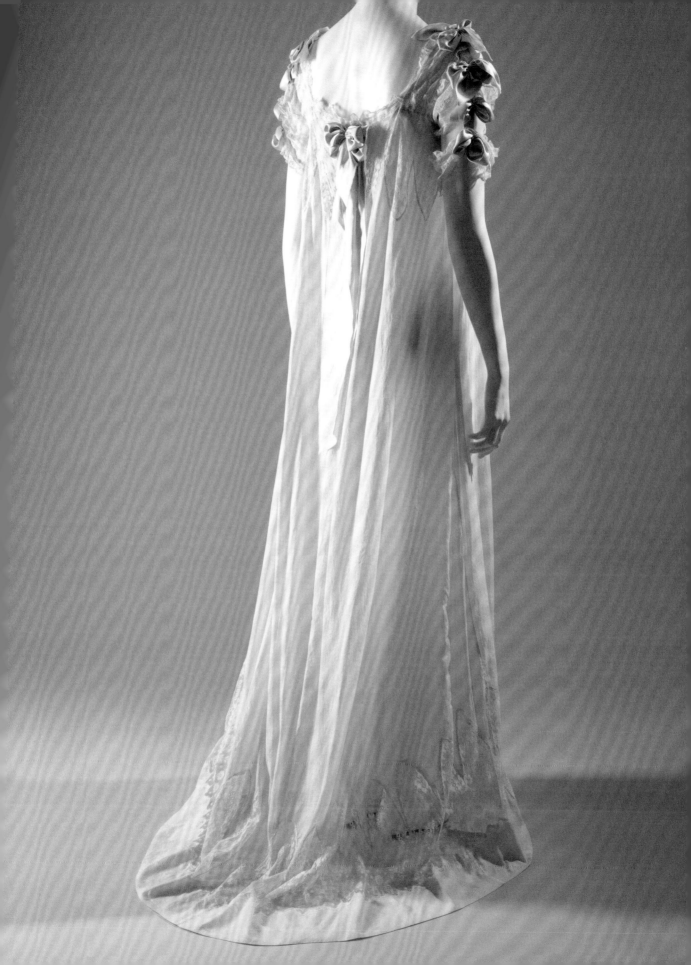

BOUDOIR CAP / *EMBROIDERED SILK NET, SILK RIBBON, SILK FLOWERS ca.1915, USA*

Boudoir caps from the early twentieth century were often made in feminine, pastel silks that complemented designs for nightwear and lingerie. The caps could be worn to keep a woman's hair in place when she slept, and also to maintain a neat appearance while she got ready in the morning. "With the elaborate coiffure now in vogue, it is wearisome to the body and soul – besides being bad for the hair – to submit to the trouble of arranging, or having it arranged, at an early hour of the morning," according to Vogue *in 1912. The purchase of an airy boudoir cap was suggested, as "no dainty woman wishes to appear untidy or unlovely at any hour of the day."[1] In addition to sparing a woman the inconvenience of restyling her hair, boudoir caps could also save her the expense of a trip to the salon.*

[1] "The Parisian Trousseau Affects Bewitching Simplicity,"
 Vogue (May 1, 1911): 36.

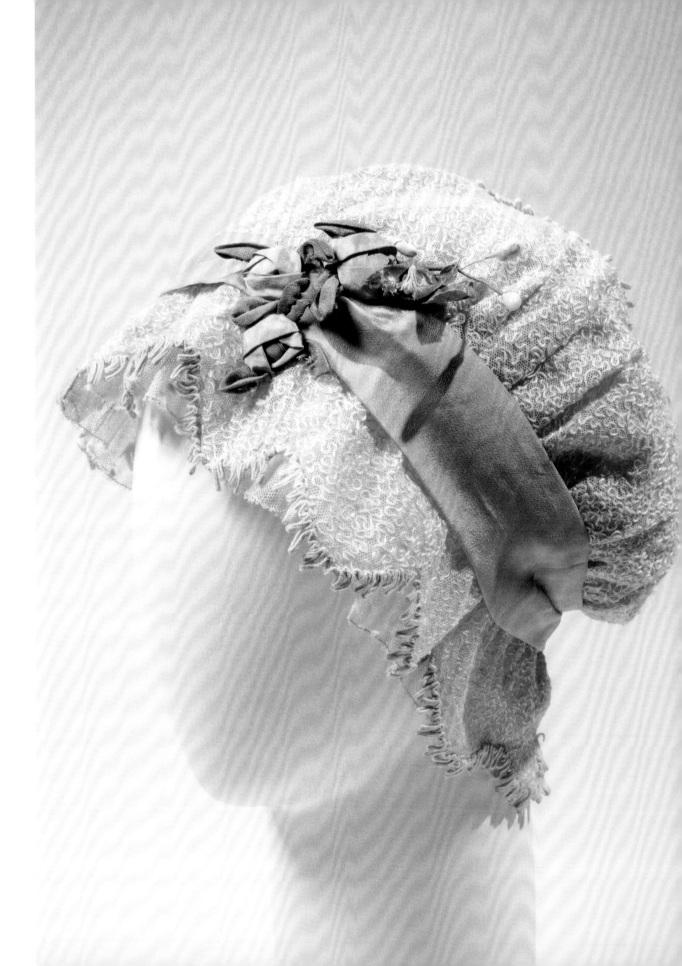

LA MULE / *CHARLES MARTIN, 1913*

From *Modes et manières d'aujord'hui*,
(Paris: Par Maquet, 1913)
Fashion Institute of Technology/SUNY,
FIT Library Special Collections and
FIT Archives, New York, NY, USA.

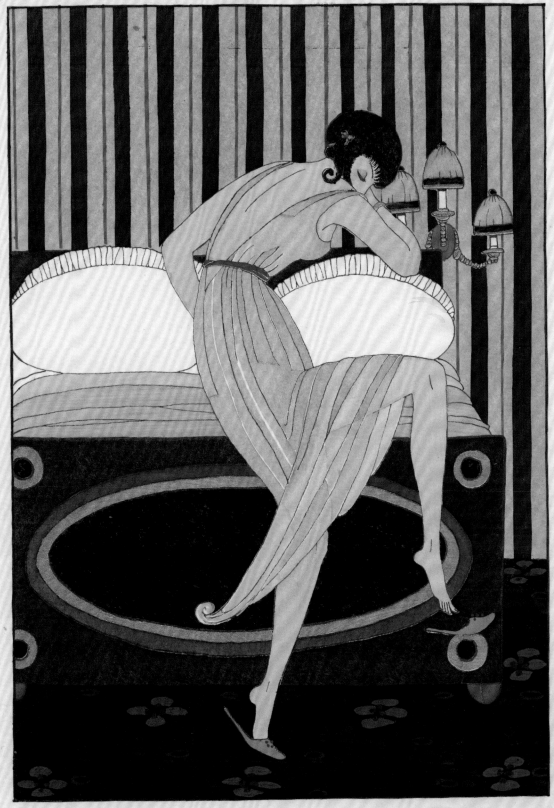

La Mule

Ainsi le long des haies dansent les chevreaux.

LA BELLE MATINEUSE / *GEORGE BARBIER, 1914*

From *Modes et manières d'aujord'hui*,
(Paris: Par Maquet, 1914)
Fashion Institute of Technology/SUNY,
FIT Library Special Collections and
FIT Archives, New York, NY, USA.

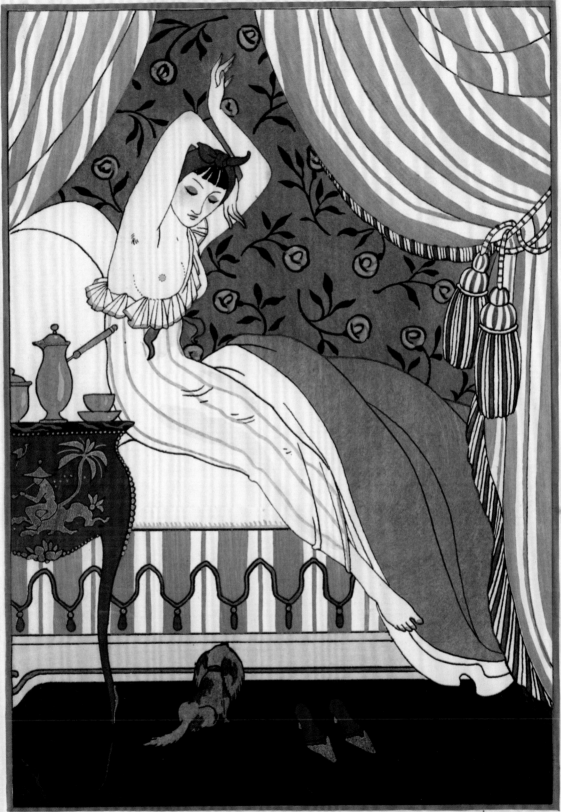

G. BARBIER 1914

La Belle Matineuse

Je t'ai connue à ton matin, ô belle Matineuse! Souviens-toi.....

TEA GOWN / *SILK CHIFFON, MINK, LACE, SILK FLOWERS, VELVET RIBBONS ca.1918, USA*

Tea gowns from the 1910s were often made from brightly colored fabrics in unexpected combinations. In this example, the delicate chiffon and lace overgown is trimmed with thick bands of mink – a material that is more typical and, one might argue, better suited to designs for outerwear and evening clothes. Tea gowns from this era were more often trimmed with luxurious but lighter-weight materials, such as marabou feathers.

Some early twentieth-century tea gowns had become so opulent that they became a subject of satire. An article in Life *magazine described a fictional lady named "Mrs. Iddington Islington Addington," who wore a tea gown that cost $1,000[1] – or nearly $24,000 today.[2]*

[1] "All Dukes Take Notice!" *Life* (August 10, 1911): 233.

[2] US Inflation Calculator, accessed February 27, 2014,
 http://www.usinflationcalculator.com/

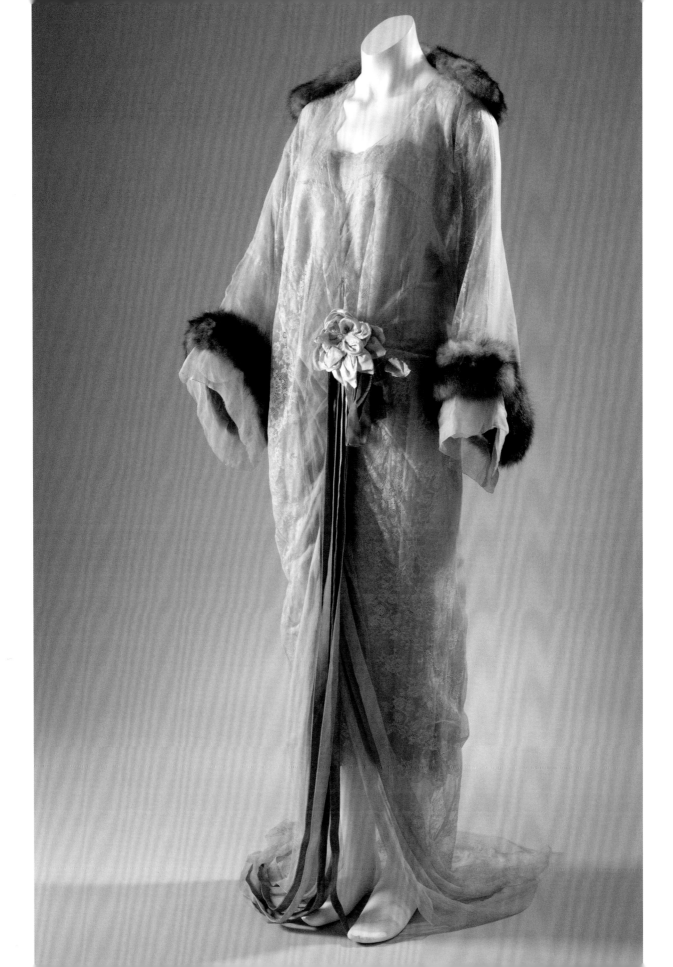

STROUSE, ADLER AND COMPANY CORSET / *BROCADED SATIN, ELASTIC, RIBBON, ca.1920, USA*

During the twentieth century, several prominent couturiers, including Paul Poiret and Madeleine Vionnet, began to design clothing that eliminated the need for a corset. The trend toward corset-less styles was of grave concern to undergarment manufacturers, and they reacted with an outpouring of advertisements and other promotional materials that discouraged women from abandoning their corsets. In 1922, one company went so far as to produce a film that highlighted the merits of a proper fitting corset.[1]

Comfort and modernity were vital to the continuance of corset wearing. By the early 1920s, many women wore corsets (also referred to as girdles) that enveloped the body from top of the waist to the hips. Some of the bestselling styles were those made from woven fabrics combined with elastic panels that allowed for greater freedom of movement.[2] Since these corsets did not cover the breasts, they were worn with separate brassieres.

[1] "Corsets in the Films," *Corsets and Lingerie* (May 1922): 38.

[2] "Elastic Lines Selling Well," *Corsets and Lingerie* (October 1922): 51.

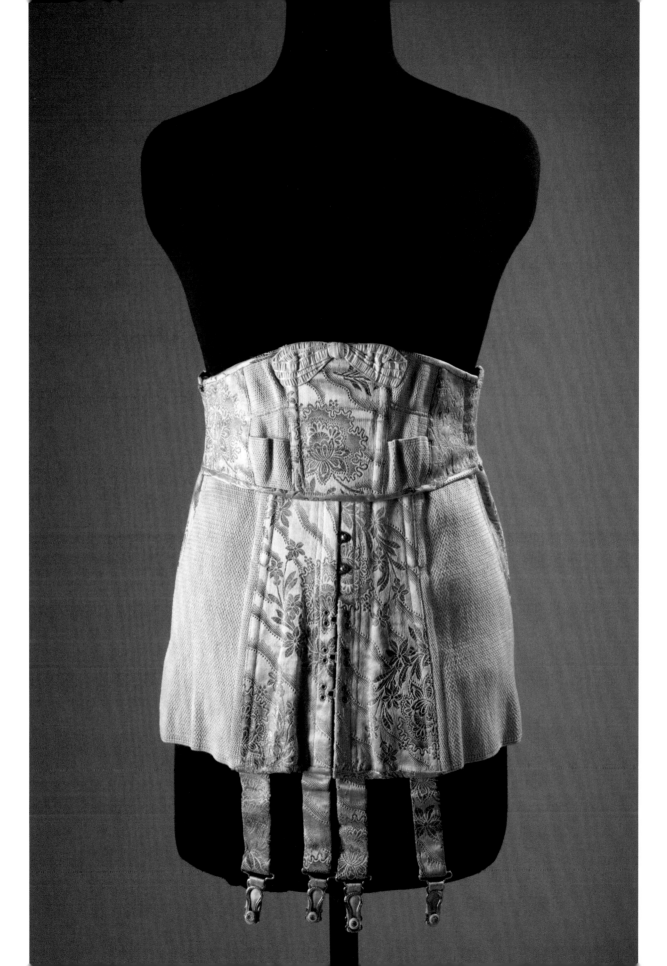

GRAND LUXE BOUDOIR MULES / *SILK BROCADE, RIBBON, AND CORD ca.1920, FRANCE*

Boudoir mules are an elegant form of house slippers. Rather than being sensibly made from warm, durable materials, such as wool felt or leather, they are characterized by their high heels, luxurious fabrics, and feminine embellishments. While boudoir mules were clearly intended for wear in the bedroom, they could also be worn at the breakfast table[1] and often acted as an ideal accessory to tea gowns. The metallic brocade used for these slippers, dating to around 1920, closely resembles the materials used on some girdles from the era.

[1] Jonathan Walford, *The Seductive Shoe: Four Centuries of Fashion Footwear* (New York: Stewart, Tabori and Chang, 2007), 146.

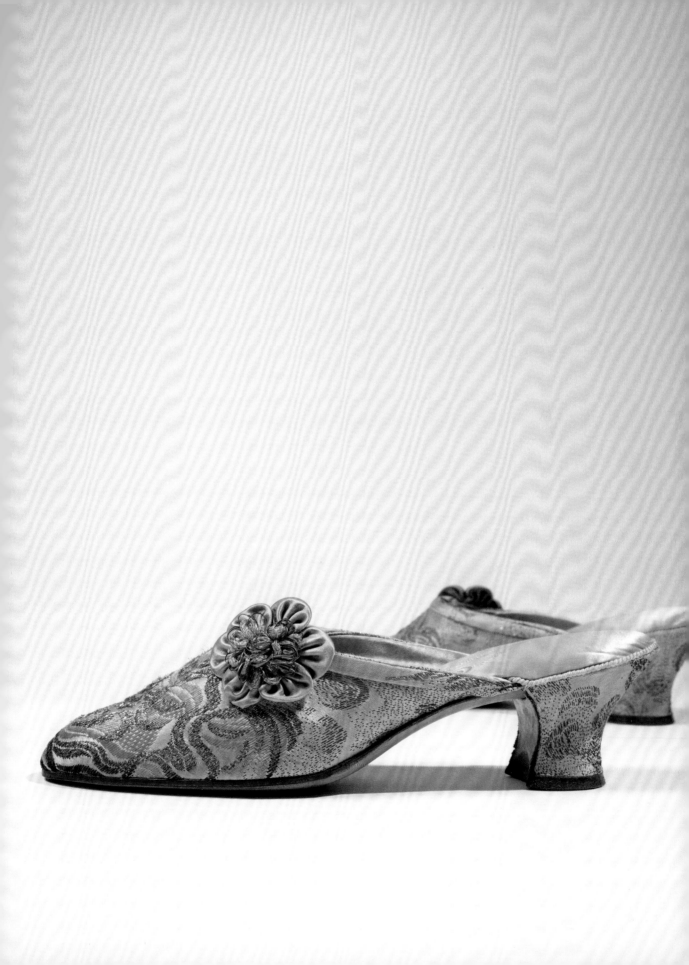

LA ROBE D'AMOUR / *ROBERT BONFILS, 1920*

From *Modes et manières d'aujord'hui*,
(Paris: J. Meynial, 1922)
Fashion Institute of Technology/SUNY,
FIT Library Special Collections and
FIT Archives, New York, NY, USA.

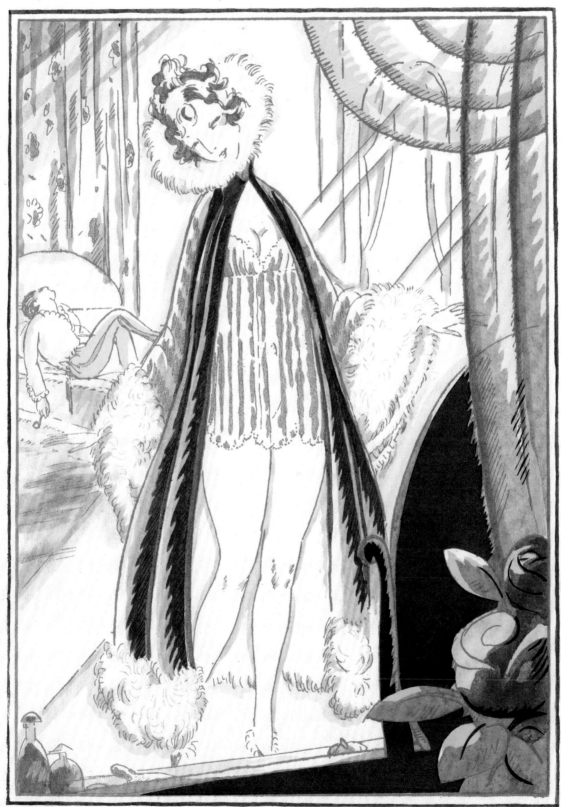

LA ROBE D'AMOUR

SAKS FIFTH AVENUE CAMI-KNICKERS / *CREPE CHIFFON, SILK SATIN, ca.1924, FRANCE*

Cami-knickers evolved from the "combinations" of the early twentieth century. Beginning in the late 1910s, these garments were made from light, delicate fabrics that facilitated a lean silhouette. By the 1920s, wide, knee-length drawers had narrowed and shortened, resulting in a sleek new style that could be worn under the tubular dresses of the era.

These cami-knickers, dating to the mid-1920s, were made in France for Saks Fifth Avenue. While embellishments on cami-knickers varied, the understated, rectangular appliqués on this example are especially modern. In 1922, the important American trade magazine Corsets and Lingerie *noted that "French lingerie still remains simple in design, but is unusually artistic."[1]*

[1] "Notes from the Lingerie Trade," *Corsets and Lingerie* (April 1922): 49.

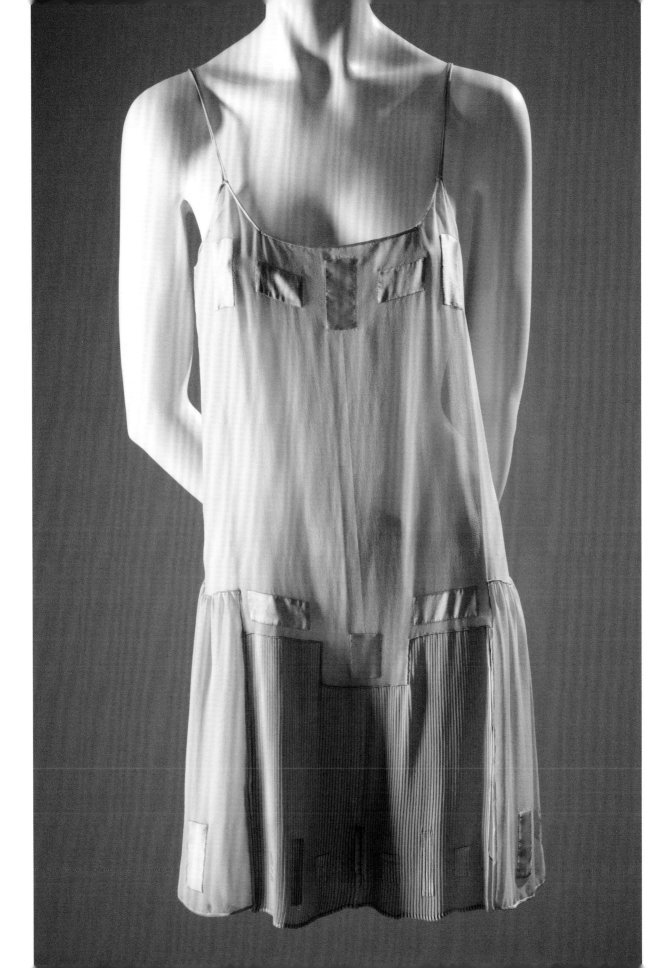

BANDEAU BRA / *SILK CREPE CHIFFON, LACE, SATIN, SILK CHARMEUSE*
ca.1924, POSSIBLY FRANCE

Bras were an essential part of many women's wardrobes by the early 1920s[1] – and they bore little resemblance to the bust supporters introduced late in the nineteenth century. In correspondence to the increasingly slender body type of the fashionable woman, most bras were designed to flatten and deemphasize the bosom.[2] Although styles varied widely, the bandeau bra was the most modern in its simplicity. Bandeaux covered and contained the breasts, but did not support them. Accordingly, they were often made from especially delicate fabrics.

The simple design of bandeau bras meant that they could be easily mass-produced. Nevertheless, many bandeaux, including this example, were meticulously custom-made at home or by professional dressmakers.

[1] Jane Farell-Beck and Colleen Gau, *Uplift: The Bra in America* (Philadelphia: University of Pennsylvania Press, 2002), 33.

[2] "Brassiere Tendencies," *Corsets and Lingerie* (April 1922): 43.

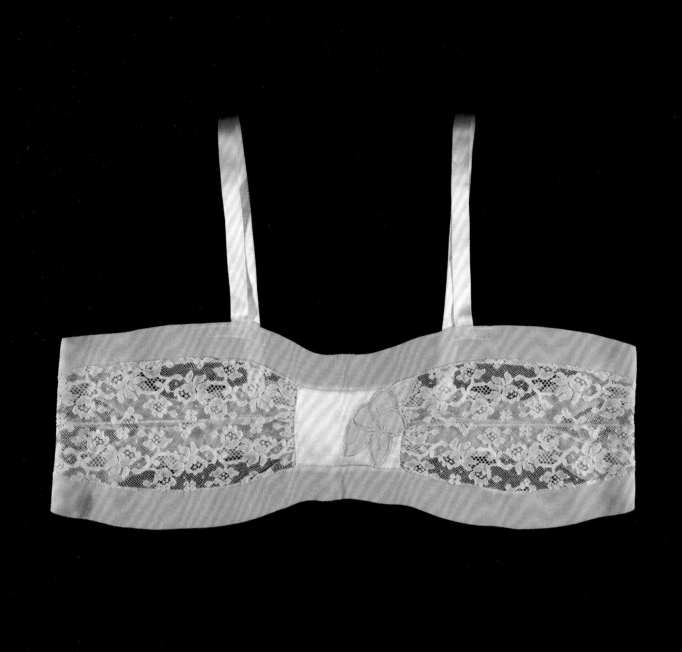

PARISIAN CORSETS, BRASSIERES AND BOUDOIR CAPS /

From *Corsets and Lingerie*,
(September, 1922): 40.
Fashion Institute of Technology/SUNY,
FIT Library Special Collections and
FIT Archives, New York, NY, USA.

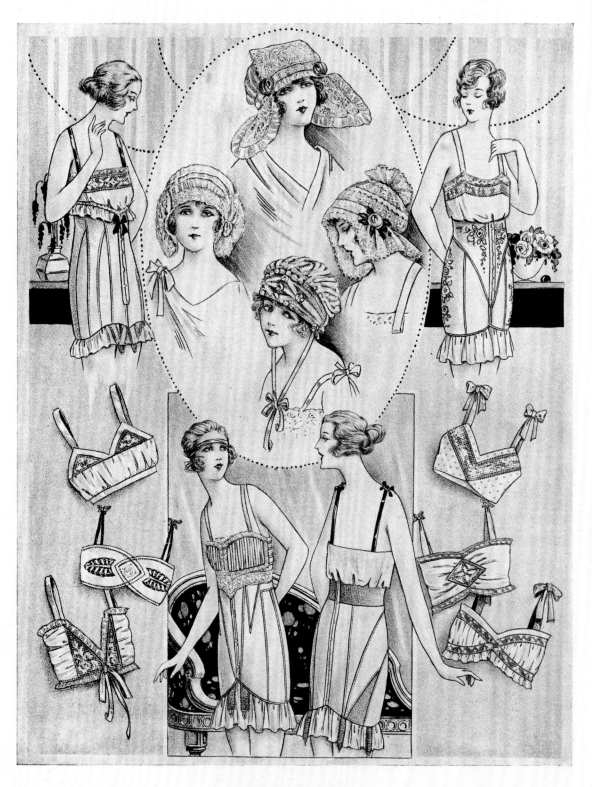

Parisian corsetieres seem to cling to the long type of corsets while their brassieres are simply bust confiners. Some very recent boudoir caps are shown.

SUZANNE BERTILLON ENSEMBLE / *HOSTESS GOWN AND SLIP, PAINTED SILK VOILE, SILK, LACE, METALLIC GOLD PIGMENT, ca.1922, FRANCE*

By the 1920s, the terms hostess gown and tea gown were used interchangeably in fashion magazines. In any of their functions, garments for wear at home often acted as mediums for imaginative designs. The outer gown of this ensemble is constructed from a single length of fabric, with a hole cut in the center for the wearer's head. A long sash ties loosely under the bust to create a high-waisted silhouette. Although the gown's construction is inventive, its embellishment is especially artistic: the griffon motif along the center and edges of the fabric is meticulously hand-stamped using gold pigment.

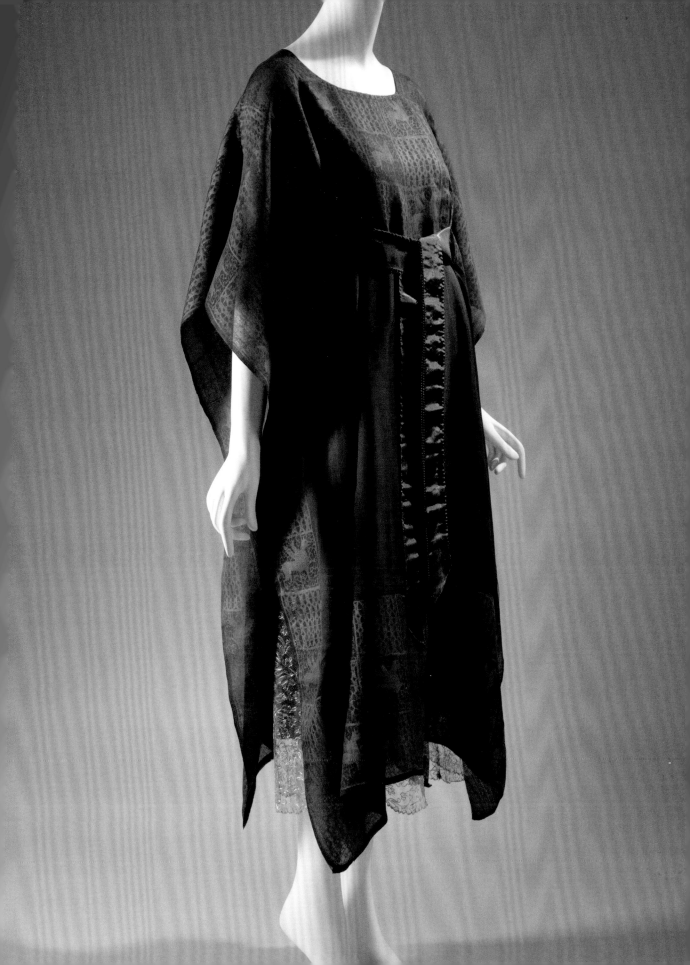

DETAIL of Suzanne Bertillon ensemble
Hostess gown and slip, painted silk voile, silk,
lace, metallic gold pigment
ca.1922, France

FORTUNY *DELPHOS* TEA GOWN / *PLEATED SILK, GLASS BEADS ca.1925, ITALY*

Fortuny introduced his Delphos gown around 1907. Its slender silhouette, inspired by drapery from ancient Greek sculpture,[1] *is crafted from finely pleated silk that skims the wearer's body. Intended for wear without a corset, the Delphos initially functioned primarily as a tea gown, but its function evolved over time. As Valerie Steele explained in her book Paris Fashion, tea gowns had "moved out of the boudoir, first to the dinner table and the drawing room, then to the dance floor, and eventually, in the 1920s, into still more public realms."*[2]

Fortuny's extraordinary silks ripple around the wearer's body as she moves, but the delicate glass beads sewn along the gown's seams ensured that the fabric remained close to the body.[3] *The exact process by which Fortuny pleated his silks remains unknown.*

[1] Anne-Marie Deschodt and Doretta Davanzo Poli, *Fortuny* (New York: Harry N. Abrams, 2001), 104.

[2] Valerie Steele, *Paris Fashion: A Cultural History* (New York and Oxford: Oxford University Press, 1988), 200.

[3] Guillermo de Osma, *Mariano Fortuny: His Life and Work* (New York: Rizzoli, 1980), 99.

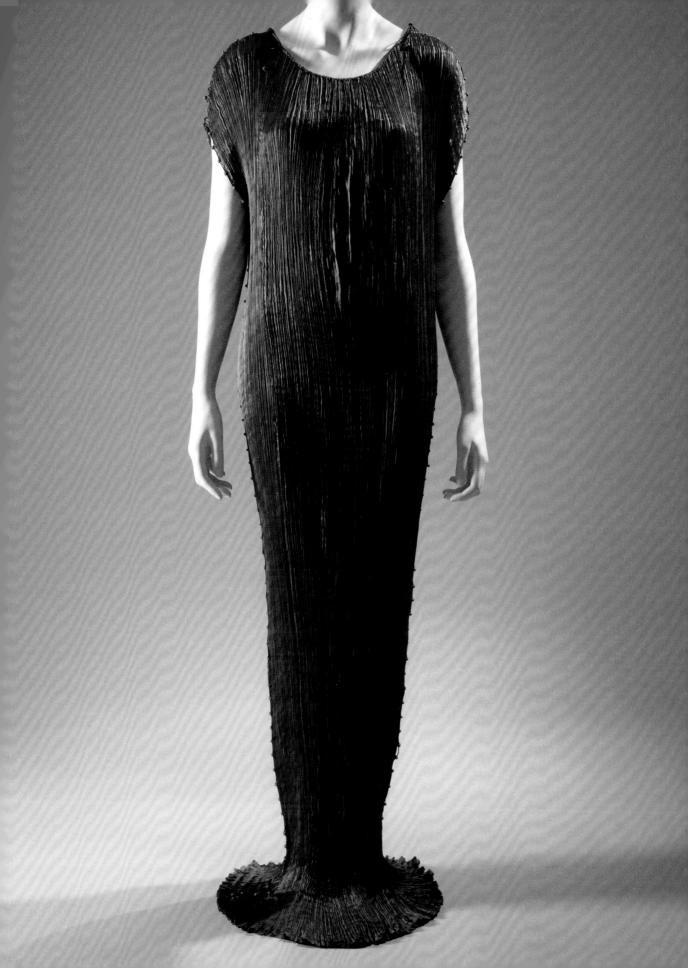

PAQUIN SLIP / *SILK CHIFFON, ALENÇON LACE, ca.1930, FRANCE*

"Modern lingerie is designed with one idea in mind – that is to be worn under clinging frocks that are intended to make the wearer look slim. Therefore, lingerie must be in the finest and sheerest of fabrics, comfortable in cut and designed to allow easy, swinging movements," explained Vogue *in 1927. "All of this sounds difficult, but it has been accomplished charmingly by the French couturiers."[1]*

Indeed, many couturiers made specialized lingerie to be worn beneath their clothing designs. This is Paquin's version of the modern slip, a garment that was devised from the "princess" style of earlier decades. The new slips were made with slim skirts and diaphanous, neutral-colored fabrics, allowing them to be as inconspicuous as possible. The donor of this slip, Mrs. William Randolph Hearst, owned another version in off-white.

[1] "Paris Lingerie Echoes the Frock," *Vogue*
 (November 15, 1927): 70.

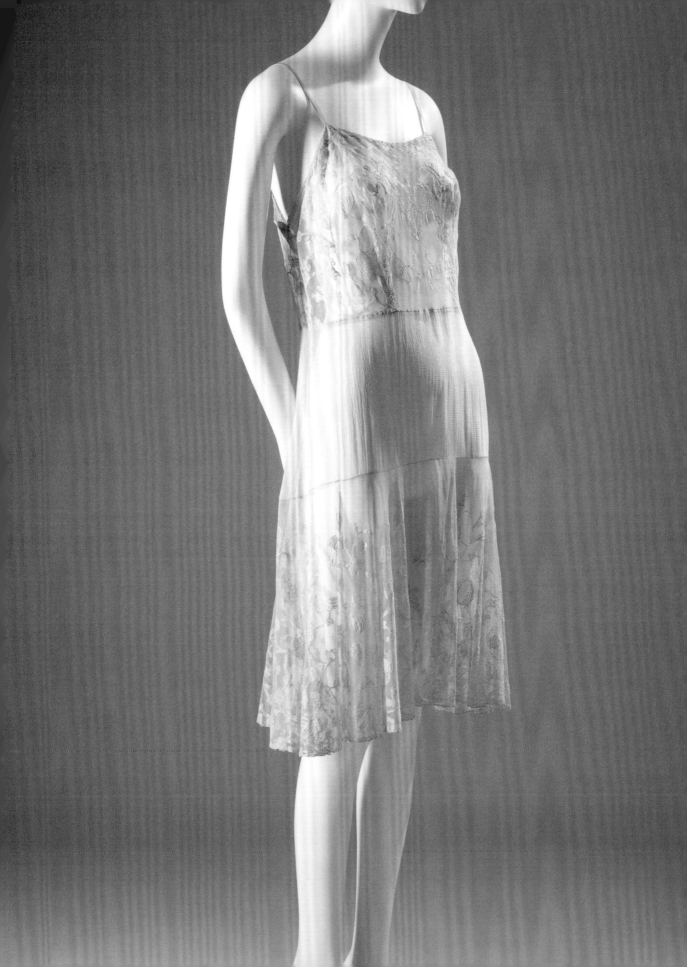

DESIGNER SKETCH FOR A SLIP BY LUCILE / *ca.1925*

Lucile Archive, 1915–25
Fashion Institute of Technology/SUNY,
FIT Library Special Collections and
FIT Archives, New York, NY, USA.

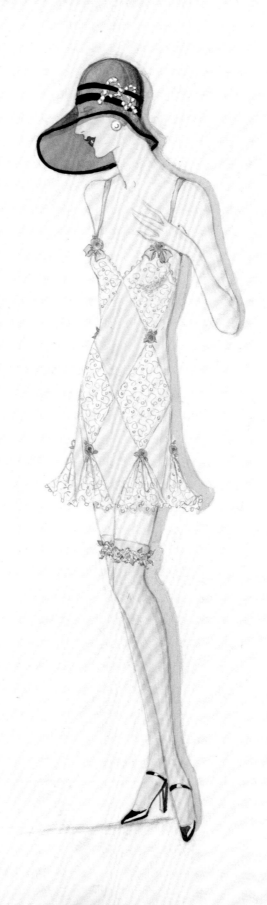

LOUNGING SET */ ROBE AND MATCHING BLOUSE, SILK, ca.1930, PROBABLY USA*

It is likely that this robe and blouse were part of a set of lounging pajamas, and were thus originally worn with a pair of matching pants. Lounging pajamas began to appear in the pages of Vogue *during the late 1910s, and they were regularly featured over the course of the following decade. Many styles were influenced by Asia and the Near East, and featured loose tunics or kimono-style tops over wide-legged trousers. The fabrics were often vividly hued.*

As pajamas became more fashionable, their role within women's wardrobes expanded. By the early 1930s, they were worn not only for lounging in the privacy of one's home, but as hostess pajamas. One writer observed in 1931 that pajamas had "left the bedroom for the living room."[1]

[1] Tom Sims, "How Pajamas Came Down Stairs," *Life* (April 24, 1931): 6.

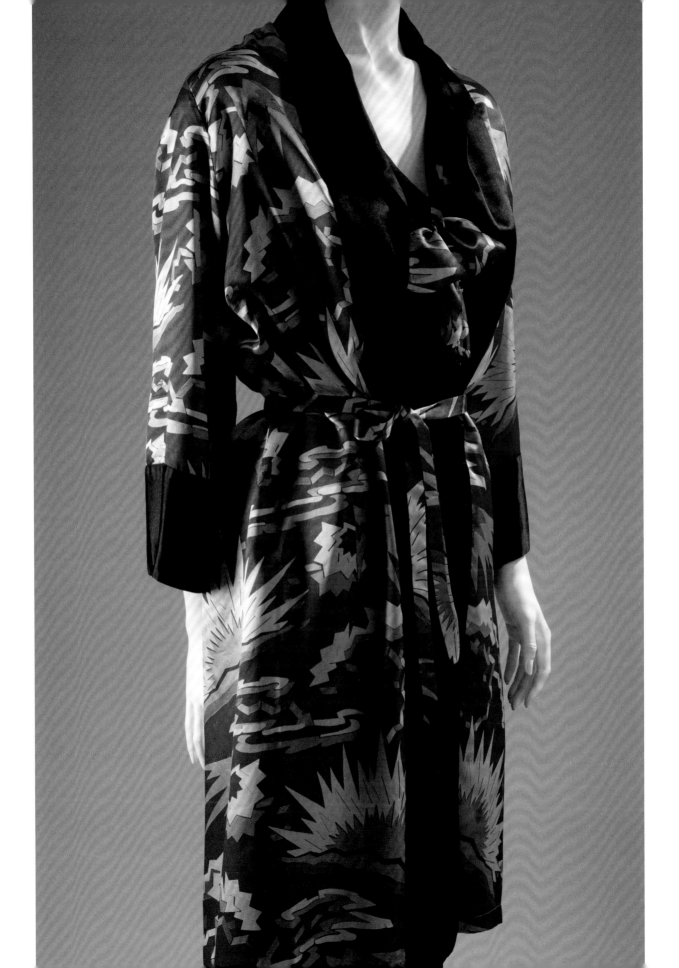

DESIGNER SKETCH FOR LOUNGING PAJAMAS */ ca.1920*

Lucile Archive, 1915–25
Fashion Institute of Technology/SUNY,
FIT Library Special Collections and
FIT Archives, New York, NY, USA.

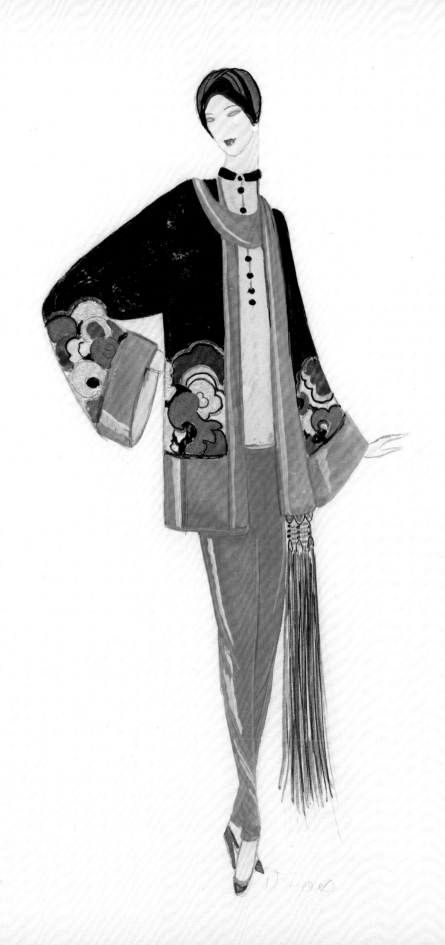

NIGHTGOWN / *SILK GEORGETTE, LACE, SILK SATIN, ca.1933, USA*

Intimate apparel sometimes looked similar to eveningwear during the 1930s. This nightgown, for instance, was crafted using bias cut fabric – a dressmaking technique that was integral to designs for outerwear. Features such as the long, sweeping hemline and low-cut back were also seen on many fashionable evening gowns of the era.

In spite of these similarities, 1930s nightgowns are easily identified by their embellishments, such as the lace insets, floral appliqué, and ruffled straps of this example. These details distinguished them not only from evening dresses, but also from other lingerie styles. "Nightdresses have almost liberated themselves from the notion of being 'undergarments,'" it was observed in La Belle Lingerie *in 1935. "They have become independent."[1]*

[1] *La Belle Lingerie* (Summer 1935), quoted in Farid Chenoune, *Hidden Underneath: A History of Lingerie* (New York: Assouline, 2005), 80.

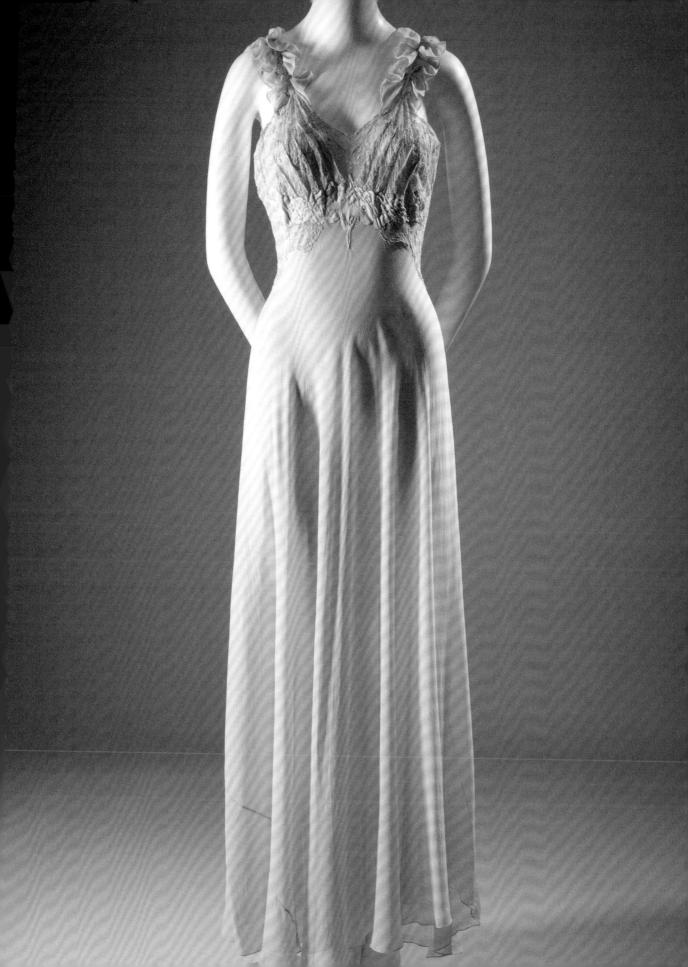

CADOLLE CORSELET / SATIN, LACE, ELASTIC, ca.1933, FRANCE

Clothing of the 1930s required a slender yet womanly silhouette. Many women relied on all-in-one girdles, also called corselets, which supported the breasts, cinched the waist, and smoothed the hips. This example, made by the French luxury lingerie brand Cadolle, features an attached lace skirt that acts as a slip. These streamlined, one-piece garments were especially recommended for wear under evening dresses.[1]

Slinky 1930s evening gowns necessitated a variety of specialized undergarments: some corselet styles were nearly backless, for example, and strapless bras – a style pioneered by Cadolle – were introduced for wear beneath new halter-neck and strapless dress styles.[2]

Renewed emphasis on the bust is underscored by this corselet's softly molded bra cups, which subtly enhance the natural breasts. While a shapely figure was again fashionable, however, women were advised to steer clear of undergarments that created an hourglass silhouette.[3]

[1] *Corsets and Brassieres* (January 1933): 34.

[2] Ibid.

[3] "The Paris Influence," *Corsets and Brassieres* (October 1934): 26.

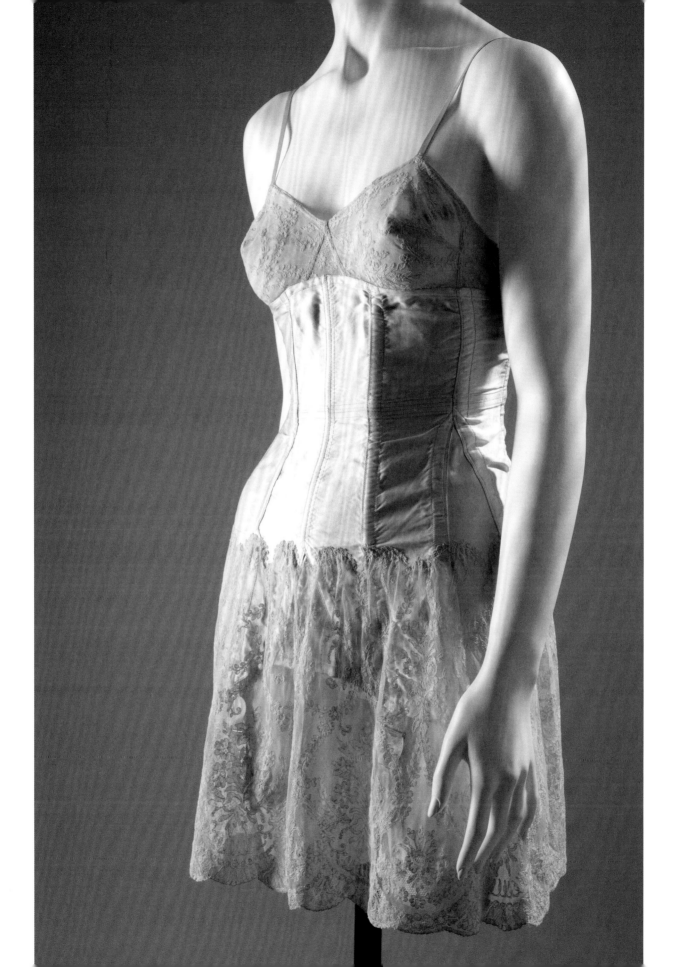

BERGDORF GOODMAN NEGLIGÉE SET / *GOWN AND CAPE, CHIFFON AND LACE, ca.1938, USA*

Negligées are lounging or sleeping ensembles that are characterized by diaphanous fabrics. This example, consisting of a slip, over gown, and matching cape, is particularly luxurious. Its silhouette follows that of many late 1930s evening gowns, which were fitted at the waist and had long, flaring skirts. Both the skirt and the cape are embellished with strips of lace that graduate in size from their top edges to their bottom hems.

Many department stores opened lingerie counters during the late nineteenth and early twentieth centuries,[1] when undergarments were simultaneously becoming more decorative and more easily mass-produced. The selections available at New York department stores were frequently featured in the pages of Vogue. *Although Bergdorf Goodman had been selling lingerie in its store for decades, in 1935 it opened its "Salon Intime," an elegant space that sold corsets, hostess gowns, negligées, and other items of lingerie.[2]*

[1] Farid Chenoune, *Hidden Underneath: A History of Lingerie* (New York: Assouline, 2005), 25.

[2] Advertisement featured in *Vogue* (September 13, 1935): 3.

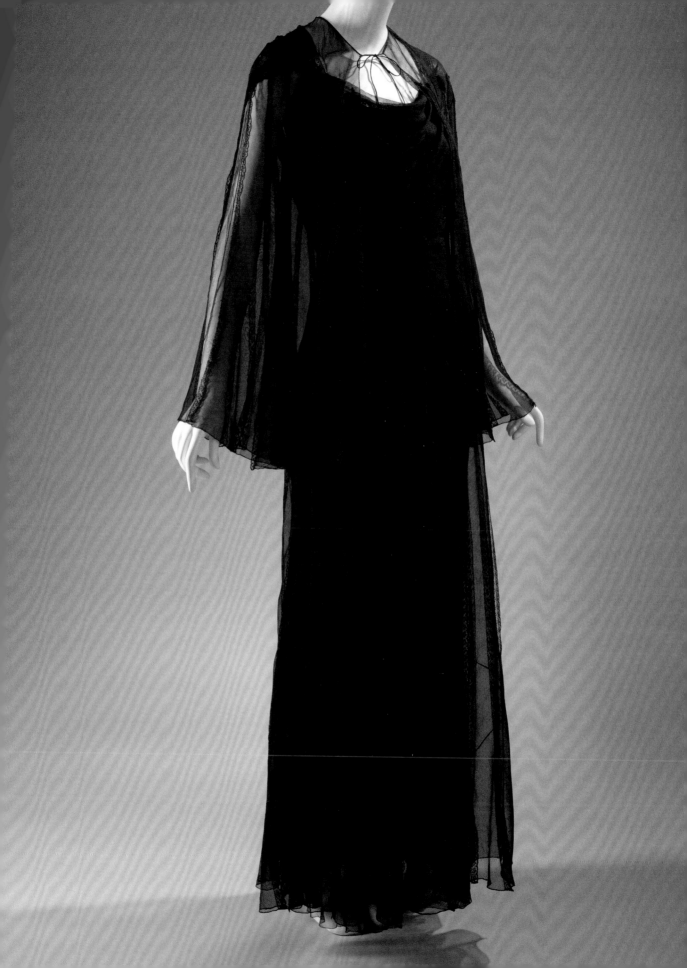

DETAIL of Bergdorf Goodman negligée set
Gown and cape
Chiffon and lace
ca.1938, USA

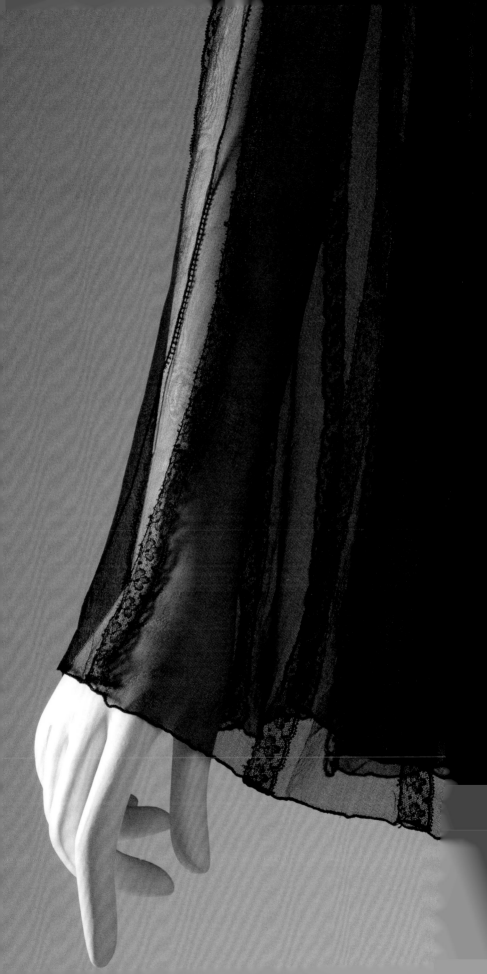

REGINE BRENNER LOUNGEWEAR SET / *LOUNGING PAJAMAS, ROBE,*
SILK CREPE, SATIN, 1939, USA

*The loosely fitted, "exotic" lounging pajamas of the 1920s had
evolved into more smartly tailored styles by the end of the following
decade. The clean, simple lines of these pajamas, as well those of
the matching robe, are highlighted by contrast trim that shows
influence from men's loungewear.*

*This set was custom-made by Regine Brenner, a high-end lingerie
designer who ran a boutique on New York's Upper West Side. It was
part of a trousseau made for its donor, Doris Goldsmith. Her new
initials, "DGZ," were embroidered onto the pocket of the robe. The
set included a handkerchief embroidered with the name of the new
bride's husband, Michael.*

(LOUNGING ROBE ON FOLLOWING SPREAD)

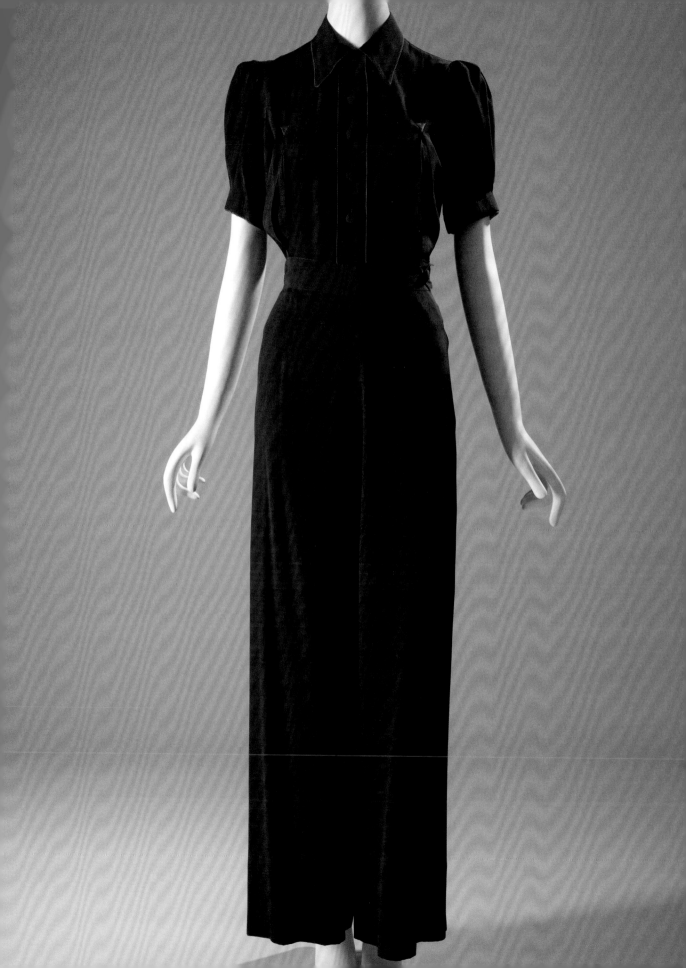

DETAIL of Regine Brenner robe
Silk crepe, satin
1939, USA

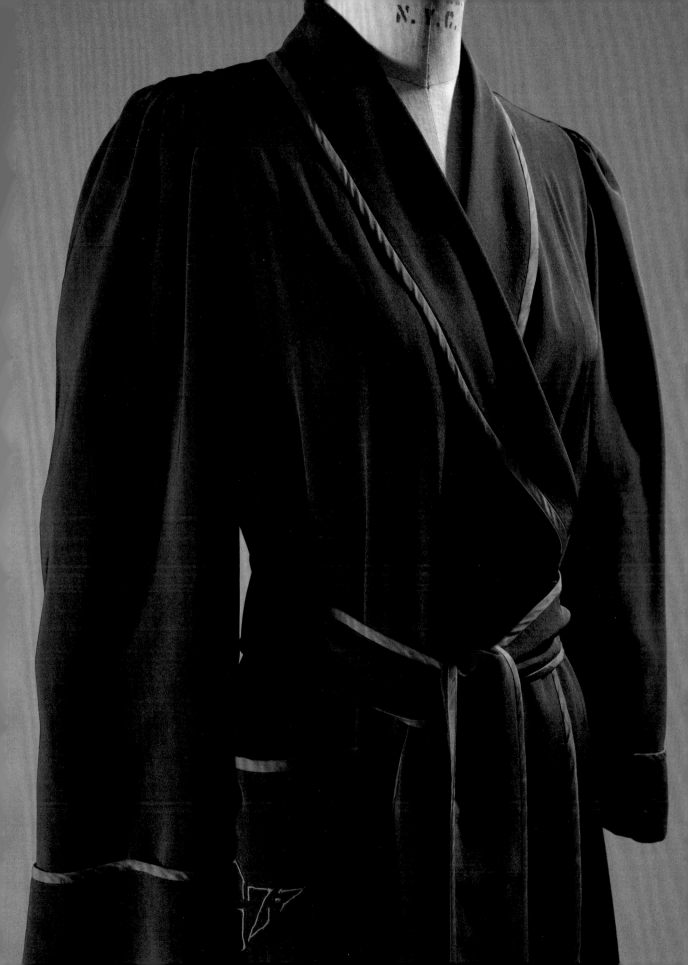

MAGGY ROUFF HALTER-NECK NIGHTGOWN / *NOVELTY WOVEN SILK, SILK SATIN, 1940, FRANCE*

Halter-neck gowns became a popular style in the 1930s. Although the revealing neckline most commonly used for evening dresses and swimsuits, it was also well suited to intimate apparel. In 1939, L'Officiel published lingerie designs by leading couturiers, noting the clean lines and cuts that allowed for freedom of movement.[1] The editorial included an illustration of a halter-neck nightgown by Maggy Rouff.

This nightgown was made by Rouff in 1940, as part of the wearer's trousseau. Rouff was known for her elegant, feminine designs, as well as her precise fabric choices.[2] The intricately woven silk used to make this example has a "patchwork" pattern, providing texture and visual interest without breaking up the gown's streamlined silhouette.

[1] "La Lingerie 1939," *L'Officiel* (February 1939): 122.

[2] Caroline Rennolds Milbank, *Couture: The Great Designers* (New York: Stewart, Tabori and Chang, 1985), 213.

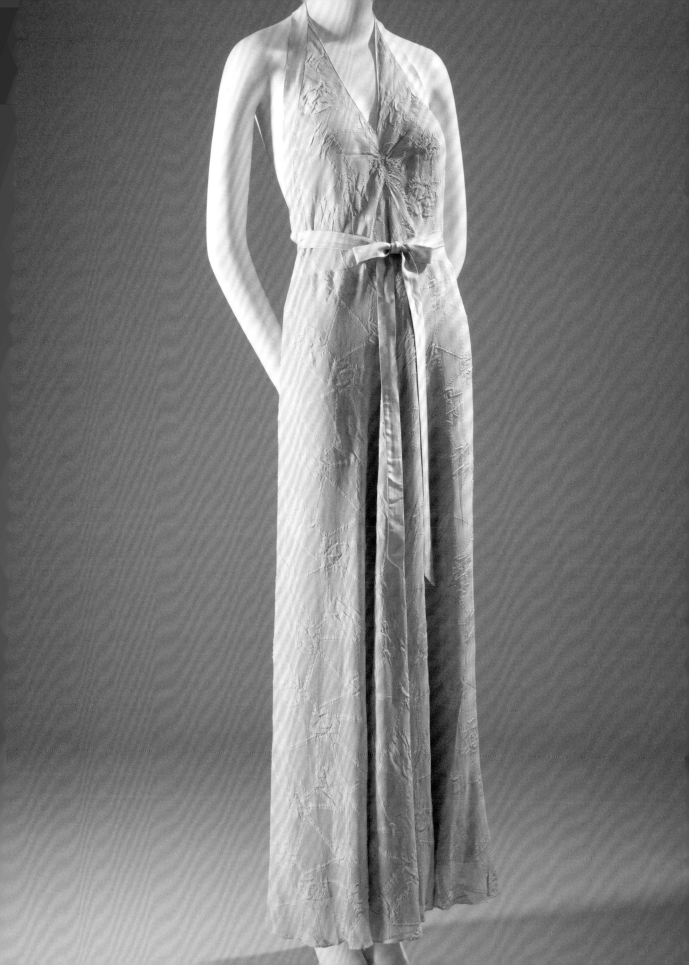

DETAIL of Maggy Rouff halter-neck nightgown
Novelty woven silk, silk satin
1940, France

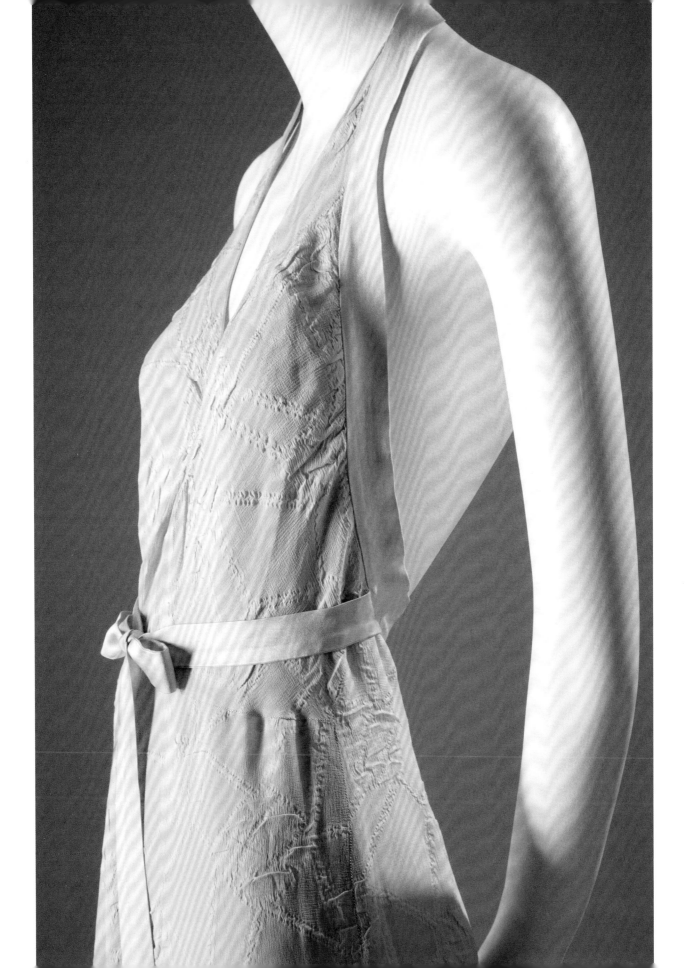

JAY THORPE LOUNGING ROBE / *PRINTED RAYON, ca.1942, USA*

Rayon was marketed as "artificial silk" upon its introduction early in the twentieth century. As a less costly alternative to silk, it was frequently used for inexpensive fashions in the 1920s. Rayon's appeal broadened during the following decade, when high-end designers such as Elsa Schiaparelli began to recognize its potential.[1] Because rayon has a supple drape and is comfortable on the skin, it also became a popular fabric for lingerie.

Rayon was essential when silk and cotton became scarce during World War II.[2] This rayon lounging robe, from about 1942, was sold at the upmarket New York clothing store Jay Thorpe. Some lingerie manufacturers from this time decreed that robes were "necessary" to women's wardrobes, as they could be worn for nighttime air raids.[3] While this robe is simply designed, details such as the beautifully scalloped, hand-finished sleeves are subtly luxurious.

[1] Dilys E. Blum, *Shocking! The Art and Fashion of Elsa Schiaparelli* (Philadelphia: Philadelphia Museum of Art, 2003), 34.

[2] Farid Chenoune, *Hidden Underneath: A History of Lingerie* (New York: Assouline, 2005), 84.

[3] Jill Fields, *An Intimate Affair: Women, Lingerie and Sexuality* (Berkeley: University of California Press, 2007), 256.

THE MUSEUM AT FIT 96.47.17 (GIFT OF MR. AND MRS. BYRON S. MILLER AND GAIL HART MILLER IN MEMORY OF THEIR MOTHER, FLORENCE HART MILLER)

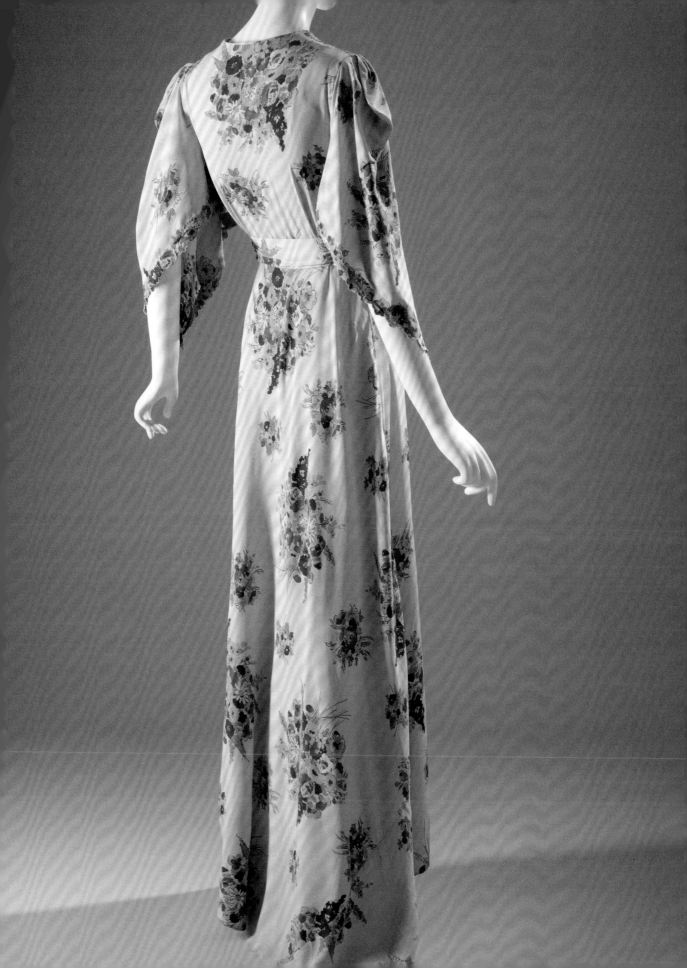

DETAIL of Jay Thorpe lounging robe
Printed rayon,
ca.1942, USA

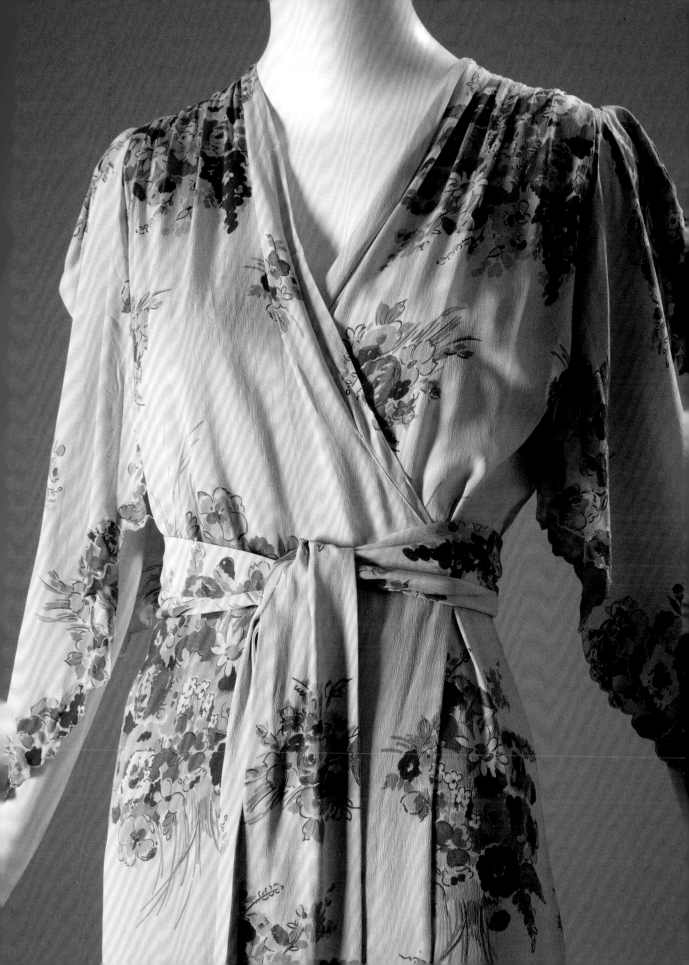

PHOTOGRAPH BY LOUISE DAHL-WOLFE / *HARPER'S BAZAAR, 1943*

Lauren Bacall wearing a white rayon slip with embroidery
and appliqué work, by Kayser
Harper's Bazaar (March 1943): 81.
Collection of the Museum at FIT, 74.84.68
(Gift of Louise Dahl-Wolfe).

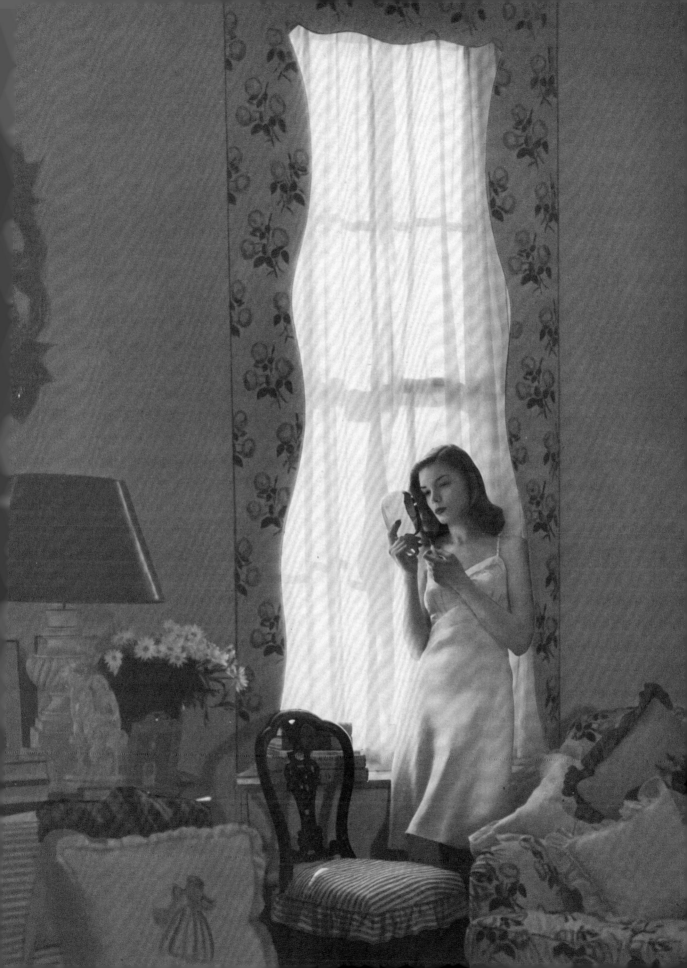

JUEL PARK / *NIGHTGOWN, SILK CREPE CHIFFON, ca.1945, USA*

This luxurious nightgown was custom-ordered for its wearer by her husband, who had it embroidered with the words "Yoni, I love you." Its maker, Juel Park, was an esteemed designer of couture lingerie. She began her business in Hollywood in 1929, and her meticulous hand-craftsmanship – as well as her store's prime location – ensured her success with an especially elite clientele. Park made Grace Kelly's trousseau,[1] and fashioned lingerie for Marlene Dietrich, Marilyn Monroe, and Elizabeth Taylor – among many others.[2]

[1] Heather John, "Lingerie: Legacy in Lace," *Los Angeles Times* (September 2, 2012), accessed March 17, 2014, http://www.latimes.com/features/image/ la-ig-lace-20120902,0,6090066.story#axzz2wFo7BsUC.

[2] "History," Juel Park, accessed March 17, 2014, http://www.juelpark.com/home.html#/history.

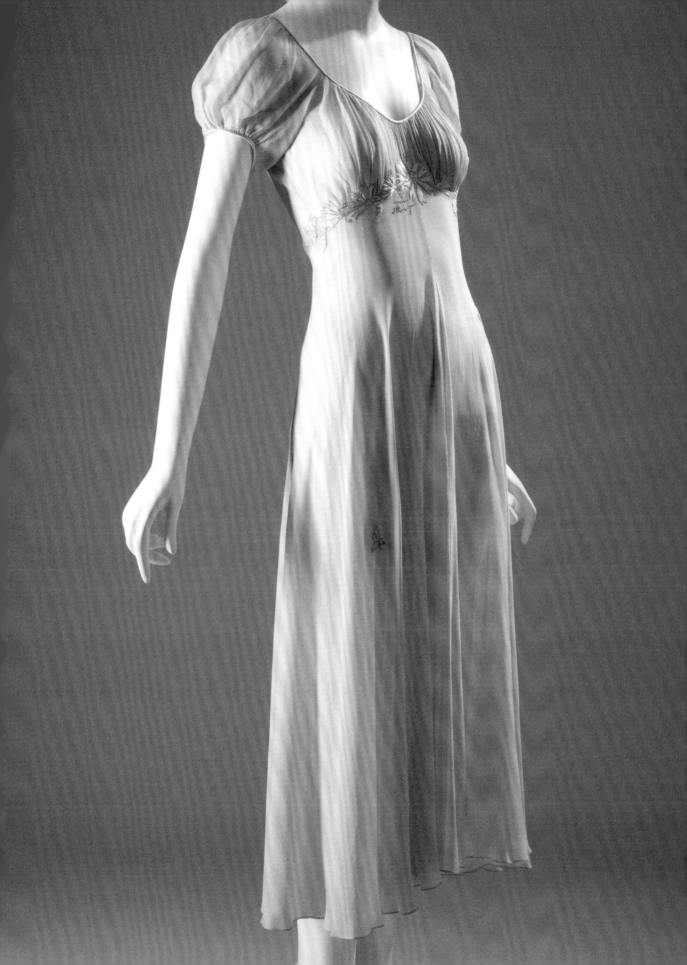

DETAIL of Juel Park nightgown
Silk crepe chiffon
ca.1945, USA

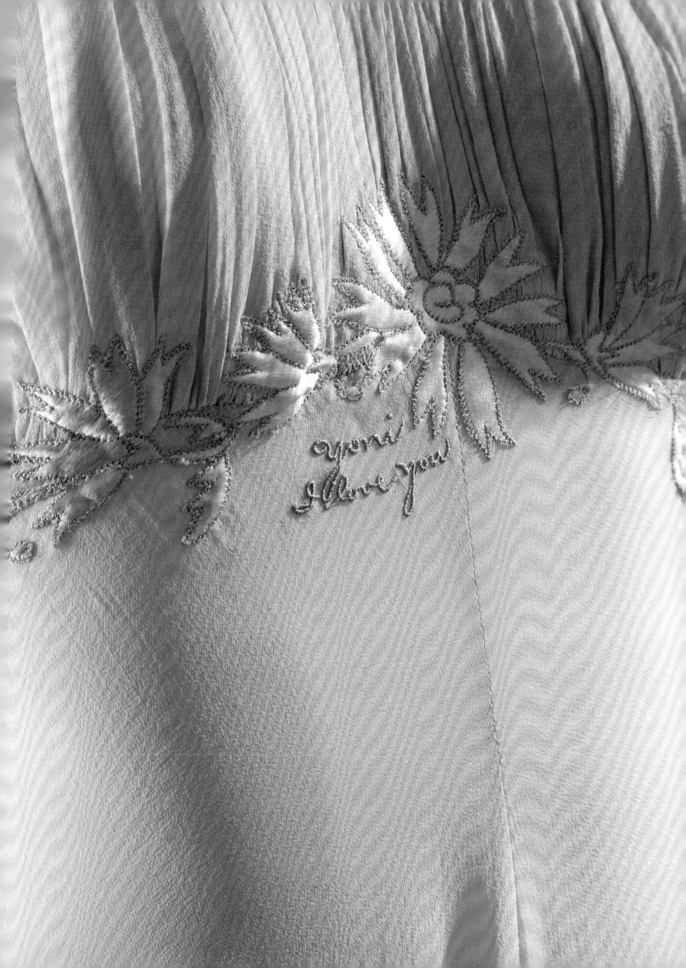

IRIS NIGHTGOWN / *PRINTED NYLON, CA.1950*

Upscale lingerie brand Iris specialized in wispy nightgowns and slips that were simply but elegantly designed. While this nightgown is cut like a basic shift, its feminine, fitted bodice is created through an elasticized neckline and sleeves, as well as a drawstring ribbon at the waist. Printed floral fabrics had long been used for lingerie, but they were especially prevalent during the early 1950s.[1]

The look of sleepwear from this era directly influenced fashion. Claire McCardell was one of the first designers to adopt the nylon fabrics typically used in lingerie and sleepwear for her designs for outer garments.[2] Some of her nylon evening dresses, also dating to the early 1950s, closely resemble the style of this nightgown.

[1] "Flower Prints for the Bedroom," *Vogue* (April 1, 1953): 136.

[2] Richard Martin and Harold Koda, *Infra-Apparel* (New York: Metropolitan Museum of Art, 1993), 66.

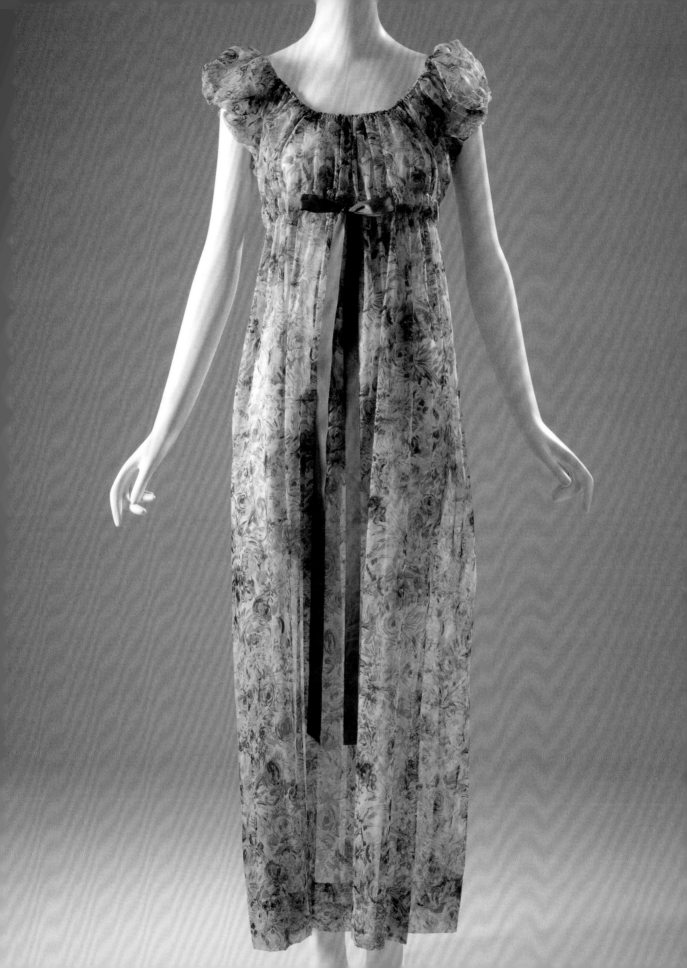

POIRETTE OVERWIRE BRA / NYLON LACE, STRETCH SATIN, 1949, USA

CHRISTIAN DIOR PETTICOAT / NYLON NET, HORSEHAIR NET, SILK TAFFETA, 1951, FRANCE

Christian Dior's 1947 "New Look" collection heralded a return to a hyper-feminine, hourglass silhouette. The bust became a focal point, and its shape was defined by a variety of highly structured bras and corselets. The cups of this 1949 Poirette bra are formed by heavy wires that arch over the tops of the breasts, rather than below them, both to emphasize and to control the bust. This bra and other, similar designs were well suited to the plunging necklines of fashionable evening dresses.

Petticoats made from tulle, net, and lightweight horsehair were often worn to maintain skirt fullness. This example by Dior was made especially for one of his elaborate couture gowns. Although the petticoat would have scarcely been visible beneath the gown's hemline, it is beautifully made.

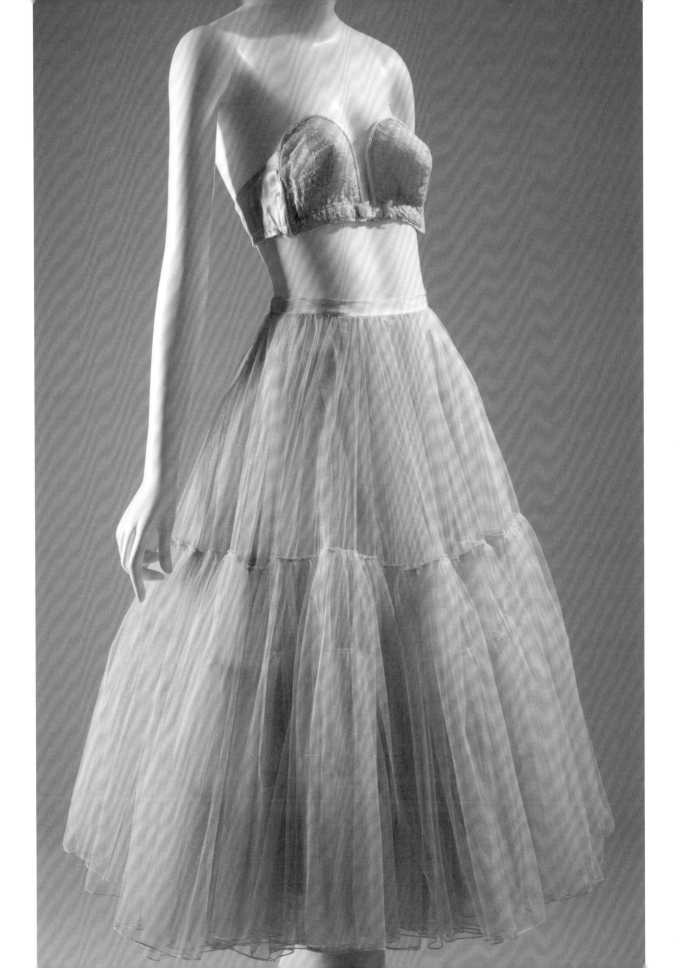

MARIE ROSE LEBIGOT for LILY OF FRANCE CORSELET / *LACE, NYLON, ELASTIC, ca.1954, USA*

"Emphasis is being placed on the small, nipped-in waistline, as the important feature for this fall's foundation silhouette," reported the New York Times in 1951. "The general contour is one of rounded, easy feminine lines with no angles . . . these fashion trends have brought new designs in foundation garments."[1] While many corselets of the 1950s resembled their 1930s predecessors, there were notable differences. Underwire cups emphasized the breasts, for instance, and strapless styles were ideal for wear beneath evening gowns.

Noted French lingerie designer Marie-Rose Legibot, who created this corselet, began to collaborate with Lily of France in the early 1950s. She was given the task of making elegant French lingerie for the American market. Legibot was especially known for her detailed craftsmanship and her use of high-end yet modern materials, such as hand-loomed lace Lastex.[2]

[1] "Fall Silhouette Nips in Waistline," *New York Times* (August 13, 1951): 20.

[2] Ibid.

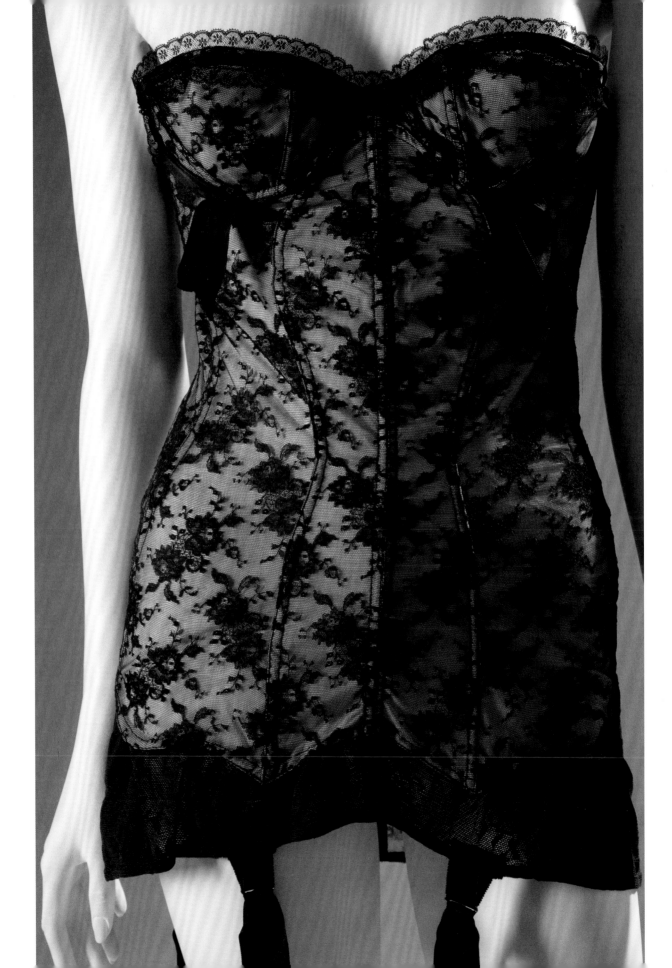

WARNER'S "MERRY WIDOW" CORSET / *EMBROIDERED NYLON, ELASTIC, ca.1957, USA*

Warner's released its first line of "Merry Widow" foundation garments in 1952. The collection was inspired by the release that same year of the movie The Merry Widow, *whose star, Lana Turner, was featured wearing an elaborate, long-line corset. While Warner's Merry Widows changed in style over the course of the 1950s (and only occasionally resembled the styles worn by Turner), they were all promoted for their ability to shape the fashionable wasp-waisted silhouette. "Audacious the way Warner's Merry Widow belittles your waist, makes the most of your charms. All at once you're inches smaller!"[1] boasted one advertisement. Merry Widows were designed to reduce the measurement of the waist up to three inches.[2]*

[1] Advertisement for Warner's "Merry Widow," featured in *Vogue* (February 1, 1952): 128.

[2] Advertisement for Warner's "Merry Widow," featured in *Vogue* (April 1, 1952): 53.

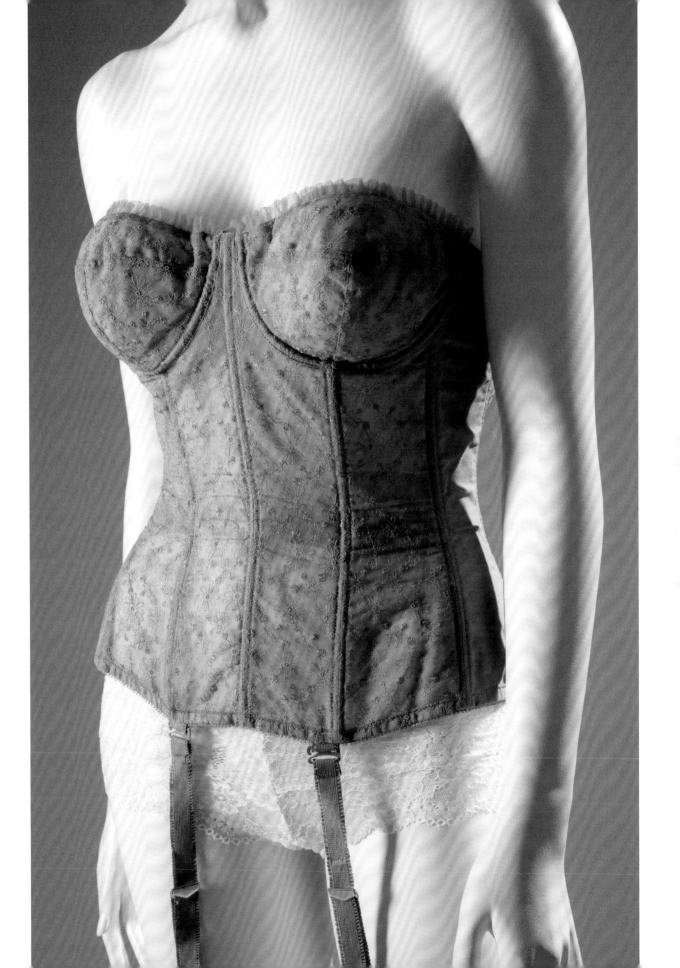

PHOTOGRAPH BY LOUISE DAHL-WOLFE / *HARPER'S BAZAAR, 1954*

Model wearing a pleated negligée in nylon tricot with
appliqué work and Alençon lace, by Vanity Fair,
Harper's Bazaar (November 1954): 167.
Collection of the Museum at FIT, 74.84.618
(Gift of Louise Dahl-Wolfe).

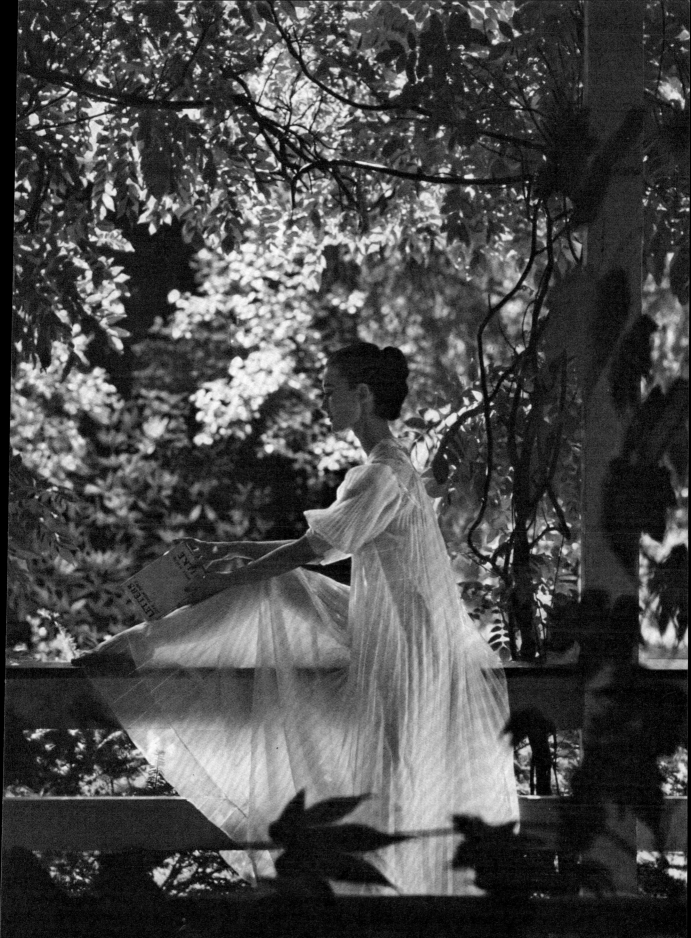

VANITY FAIR "BABY DOLL" NIGHTGOWN / *NYLON TRICOT, ca.1960, USA*

Short, billowing "baby doll" nightgowns became fashionable in the late 1950s. They were named after a style seen in the 1956 movie Baby Doll, *in which Carroll Baker – who played an innocent, teenaged bride – wore a hip-length, ruffled nightie and matching pantalets.*

In her book Wife Dressing *of 1959 designer Ann Fogarty recommended that women have at least six nightgowns or pajamas in their sleep wardrobe. "Pay as much attention to their style and fit as you do your outerwear," she advised. "The master bedroom is not a college dormitory or a camping trip . . . it is a private retreat set apart from the outside world."[1] Owning a selection of fashionable sleepwear became easier with the availability of nylon, which was inexpensive and easy to care for. Vanity Fair was especially known for making stylish, delicate nightclothes from brilliantly colored nylon fabrics.*

[1] Ann Fogarty, *Wife Dressing* (New York: Julian Messner, Inc., 1959), 44.

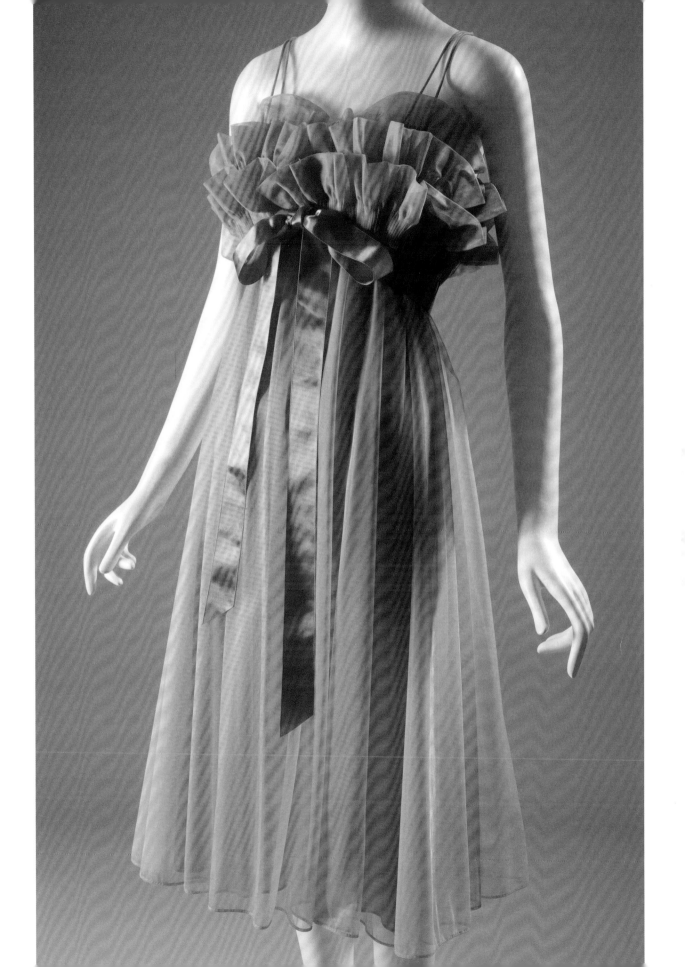

VANITY FAIR BRA AND PANTY GIRDLE / *NYLON TRICOT, ELASTIC, ca.1960, USA*

The rigid foundation garments of the 1950s gave way to increasingly flexible styles during the following decade, as a trim, youthful figure became the ideal. While this bra is fully lined, it has no inner construction, allowing the breasts to take a more natural shape.

Panty girdles smooth and contour the wearer's body from the waist to mid-thigh, and often include an extra panel for reinforcement over the stomach. They were introduced in the 1930s and were usually recommended for wear with slacks and shorts, as well as for sporting activities. In the early 1960s, panty girdles were advertised as the ideal undergarment to be worn beneath clothes that were "coming ever closer to the body."[1]

[1] Advertisement for Vyrene ® spandex fabric, featured in *Vogue* (February 15, 1962): 13.

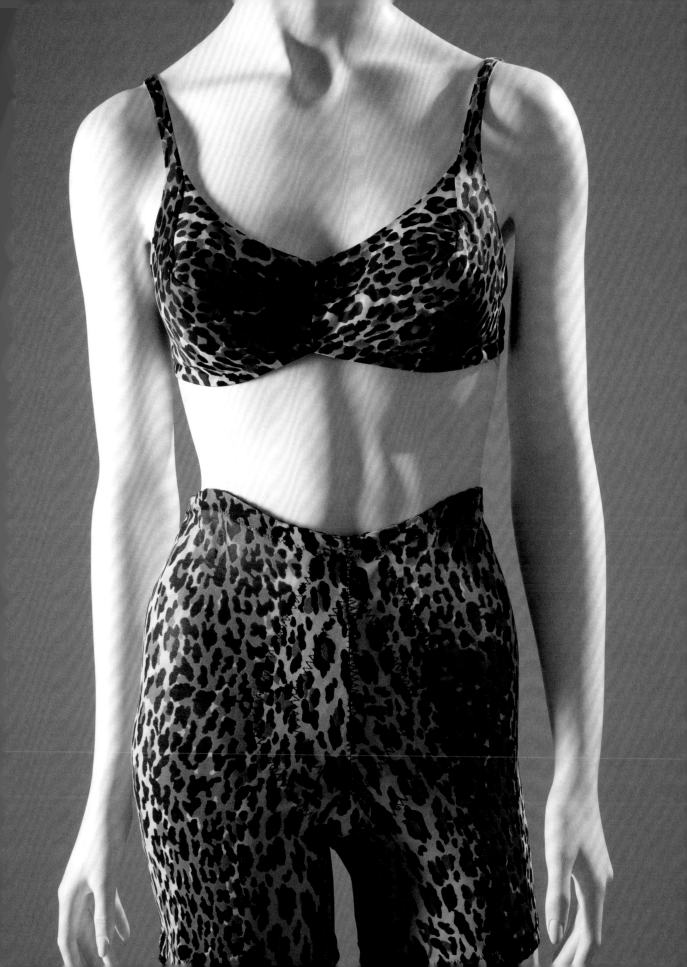

RUDI GERNREICH for EXQUISITE FORM BRA AND PANTY / *PRINTED POLYESTER TRICOT, 1967, USA*

Rudi Gernreich is widely considered to be one of the most innovative designers of the 1960s, owing in part to his provocative designs for lingerie. Many of his ideas centered on a desire to liberate women's bodies from constricting garments – a concept Gernreich first developed during the 1950s, when he eliminated padding from women's bathing suits. The designer's interest in soft, unstructured styles continued into the following decade, when many of his bras for Exquisite Form were constructed from mere triangles of stretchy fabric.

Gernreich's designs for lingerie and stockings were sometimes part of matching clothing sets, resulting in a style he referred to as "the total look."[1] This giraffe-print bra-and-panty set coordinated with an outerwear ensemble made from a similar fabric.

[1] "Fashion: Up, Up and Away," *Time* (December 1, 1967).

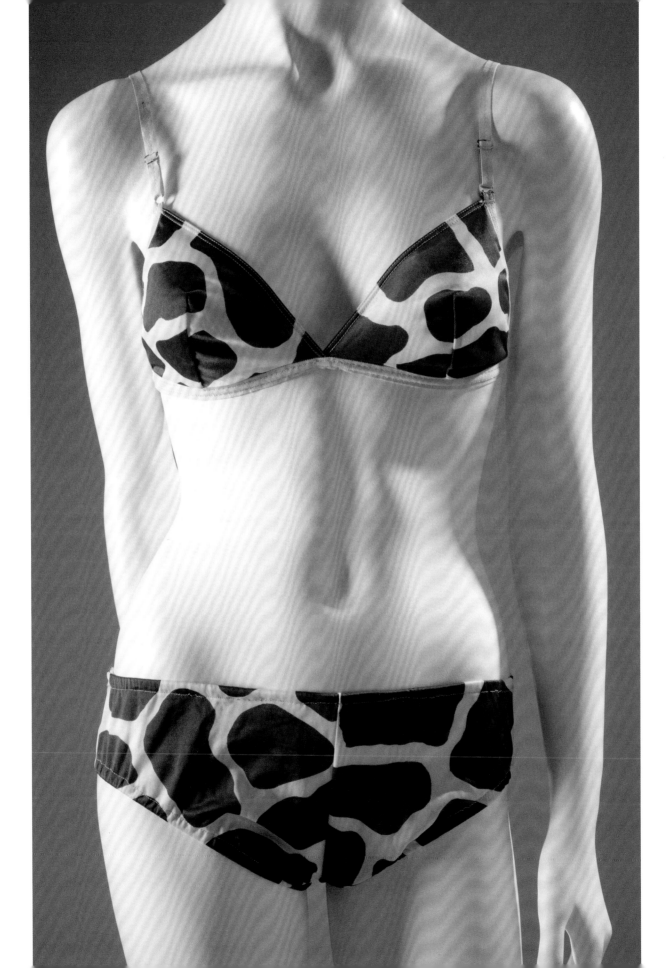

RUDI GERNREICH for EXQUISITE FORM "NO-BRA" / *SHEER NYLON, ca.1965, USA*

RUDI GERNREICH for EXQUISITE FORM HALF-SLIP / *PRINTED NYLON TRICOT, ca.1965, USA*

Time *magazine featured Rudi Gernreich on the cover of its December 1, 1967 issue, stating that "no stylesetter has capitalized with more flair on the current vogue for exposure."[1] While Gernreich's topless bathing suit of 1964 is his most notoriously revealing design, his "no-bra," introduced in 1965, was nearly as provocative – and it was certainly more marketable. Made from sheer, stretchy material, the no-bra capitalized on two 1960s trends: the acceptance of the "natural," bra-less look, and the fashion for transparent fabrics (Gernreich also designed see-through blouses[2]). While the no-bra can be directly linked to the sexually liberated 1960s, a similar style was introduced nearly twenty years earlier: in 1949, Model Brassiere sold a style called the "Illusion," which was made with sheer, flesh-colored cups that gave a "nude, very sexy appearance."[3]*

[1] "Fashion: Up, Up and Away," *Time* (December 1, 1967).

[2] Ibid.

[3] "Illusion – New Sexy Bra," *Corsets and Underwear Review* (July 1949): 120.

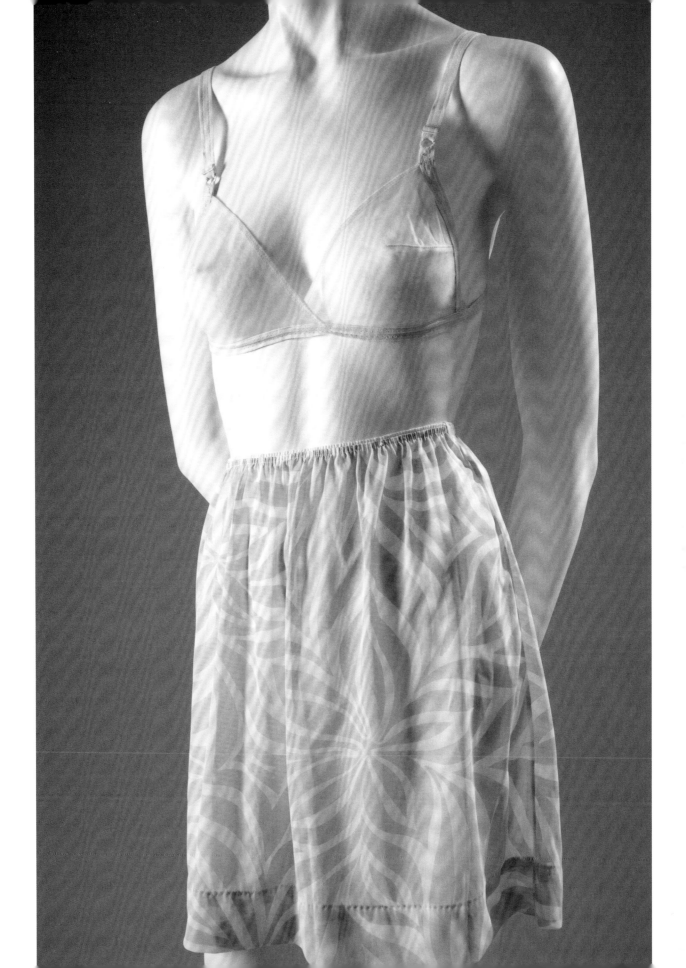

TRIMFIT HOSIERY / *STOCKINGS IN ORIGINAL PACKAGING*
NYLON AND CARDBOARD, 1967, USA

1960s miniskirts revealed more of a woman's legs than ever before. This led to many innovations in hosiery, from wildly patterned stockings to "stocking boots," made from stretchy materials that tightly encased the wearer's feet and calves. Full-length tights – rather than separate stockings held up by garters – were offered as a practical solution for wear beneath ever-shorter hemlines.

Although stockings may be considered a more "old-fashioned" alternative to tights, this violet-blue pair was clearly marketed toward young consumers. The stockings are part of a line produced by Trimfit in 1967, inspired and endorsed by the iconic model Twiggy – who wore some of these colorful styles in an extensive Vogue *editorial that same year.[1]*

[1] "What Makes Fashion Tick," *Vogue* (November 15, 1967): 126–35.

BRIGHT
BLUE
SIZE 8½
$.69
MADE IN
U.S.A.

Trimfit HOSIERY

INSPIRED BY **Twiggy**
FOR THE "NOW" PEOPLE

PUCCI BODY STOCKING / *PRINTED LYCRA/SPANDEX BLEND, 1969, ITALY*

Emilio Pucci designed for lingerie brand Formfit Rogers during the late 1960s and early 1970s, lending his colorful, boldly printed fabrics to everything from slips to lounging robes. Although foundation garments in the 1960s eschewed the exaggerated curves of the previous decade, they were sometimes worn subtly to enhance the wearer's form. A Vogue *editorial in 1969 entitled "The Naturals" featured body stockings as one of the "sleek new underthings looking less than they are . . . doing more than they look."[1] This example is made from a Lycra/Spandex blended fabric, referred to as "power net," that offers both control and comfort. Its low-cut back, high-cut briefs, and snug, seamless fit ensured that it was almost undetectable beneath revealing styles of clothing.*

[1] "The Naturals," *Vogue* (August 15, 1969): 114.

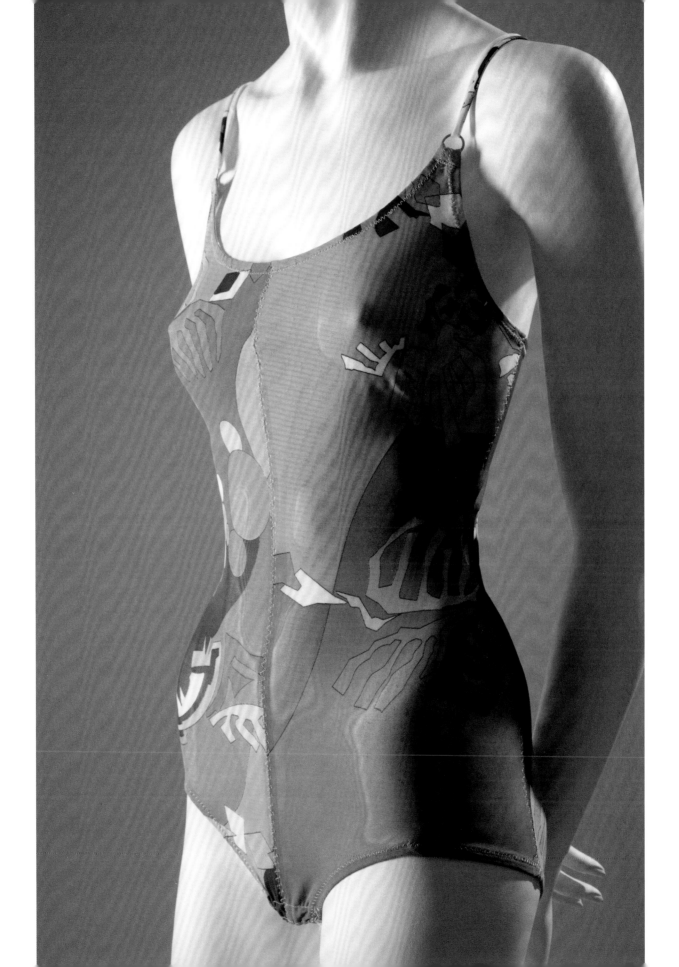

VALERIE PORR LOUNGING PAJAMAS / *PRINTED SILK, 1976, USA*

Many 1970s clothing styles were inspired by fashions of the past—particularly those from the 1930s. This included a renewed interest in lounging pajamas, which were often designed with loose, wide-legged trousers. In 1974, Corset, Bra and Lingerie Magazine *observed that "the Big Lounge Look is pajamas…they're pretty, comfortable and just right for in-home entertaining of two or many more."[1]*

While the silhouette of these pajamas may have been inspired by vintage styles, their print was decidedly of-the-moment. From the late 1960s through the mid-1970s, emphasis was placed on all things "natural," including the nude body.[2] This could be manifested through the actual design of clothing (Rudi Genreich's "no-bra" being a prime example), but it could also be referenced in other ways, such as the bold, oversize print of a nude woman on this fabric.

[1] *Corset, Bra and Lingerie Magazine* (May 1974): 16.

[2] Linda Welters, "The Natural Look: American Style in the 1970s," *Fashion Theory* 12 (2008): 501.

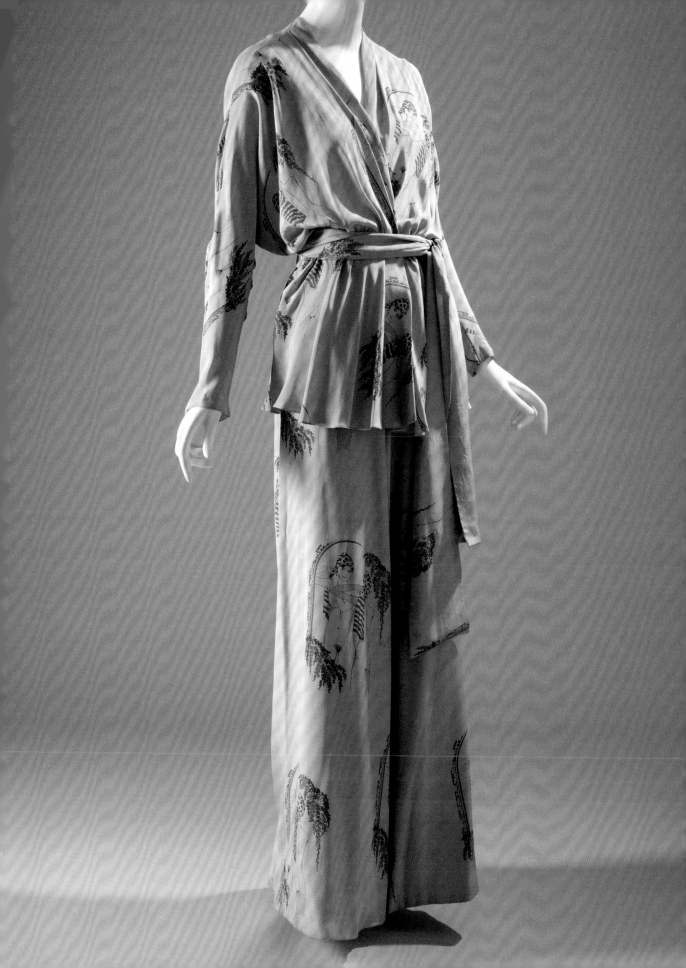

DETAIL of Valerie Porr lounging pajamas
Printed silk
1976, USA

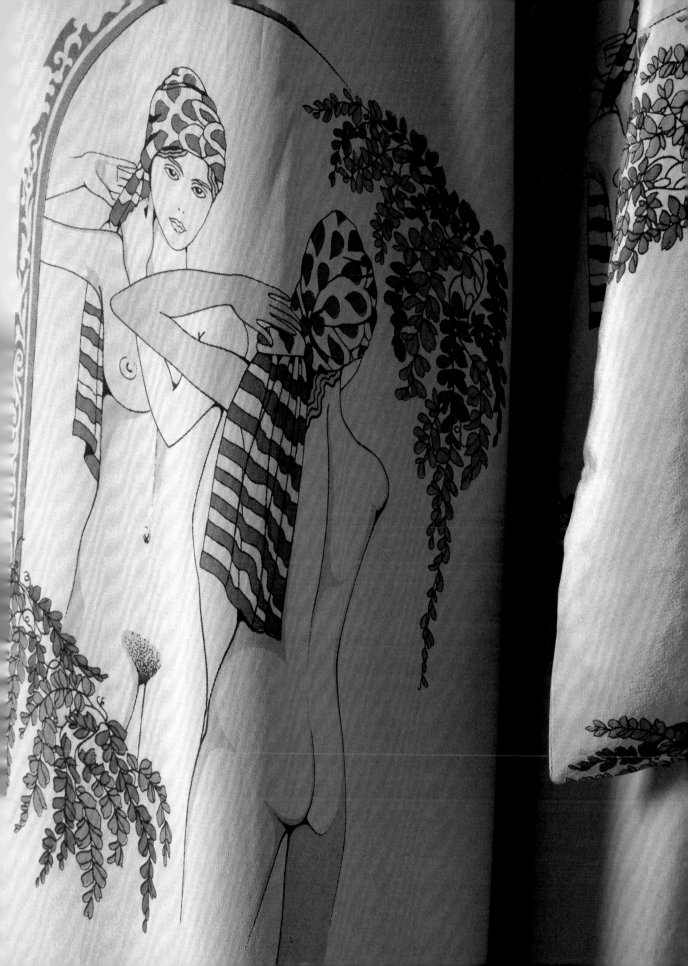

SHELLY EASY RIDER BRA AND PANTY / *SHEER NYLON, ca.1977, SOUTH AFRICA*

The 1960s fashion for uninhibiting bra styles carried into the following decade. Although slightly more substantial than Rudi Gernreich's "no-bra," this example was made to emphasize natural-looking breasts. The panties, however, are skimpier than their predecessors. Cut higher on the leg and lower on the waist, they had evolved into a more pronounced "bikini" style. In Vogue *a similar set was described as "practically nothing to wear under everything."*[1]

[1] "Vogue Boutique: Fall Finds Around Town," *Vogue* (September 1, 1972): 219.

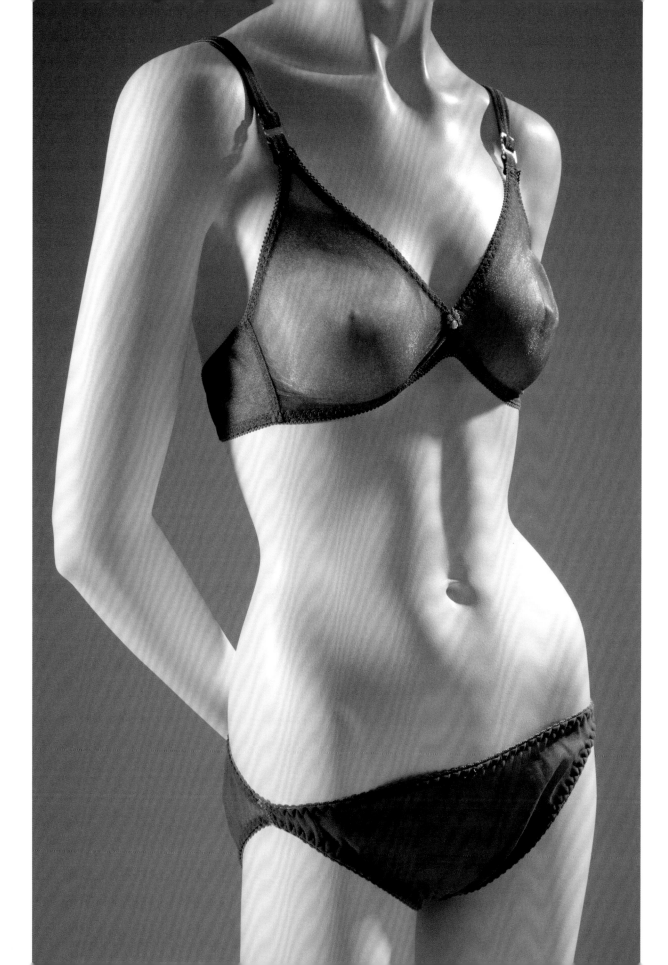

FERNANDO SANCHEZ DRESSING GOWN / *CHIFFON WITH MULTICOLOR METALLIC PINSTRIPES*

Vogue *announced the "start of lingerie fever" in 1978, describing a trend for luxurious intimate apparel that was led by the American designer Fernando Sanchez.[1] Although he made nearly every kind of lingerie, Sanchez was best known for his sensuous lounging clothes.*

This dressing gown exemplifies a hallmark of Sanchez's work: his ability to create lingerie garments that could be worn in multiple ways, and in different settings. Its soft construction and lightweight fabric provide it with the feeling of ease essential to loungewear, while the fashionable, cutaway hemline and metallic threads indicate it also could have been worn as an evening dress.

[1] "The Sanchez Impact: The Start of Lingerie Fever," *Vogue* (January 1, 1978): 138.

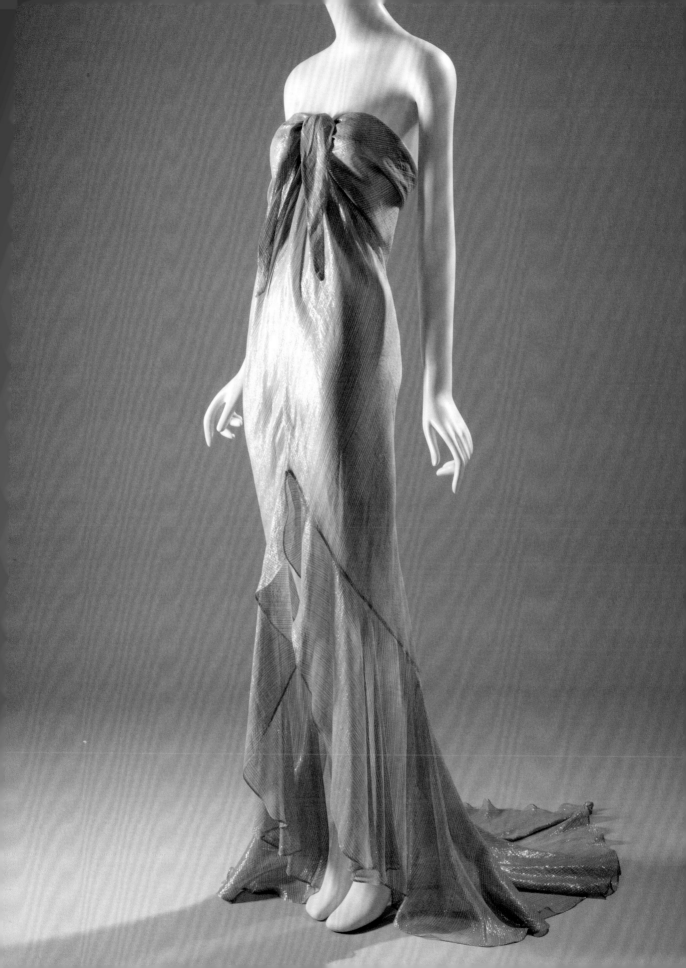

PATRICIA FIELDWALKER TEDDY / SILK CHARMEUSE, LACE, ca.1988, USA

The one-piece teddy was derived from the combination undergarments of the 1920s. It took on a sexy new look in the 1980s, when it was recommended for sleepwear. In 1988, an article in Intimate Fashion News *reported that designers continued to "tempt the consumer to add more styles to her teddy wardrobe," describing opulent looks with "briefly cut silhouettes . . . high-cut legs and revealing spaghetti-strap bodices. And as an ultra feminine touch, lace is often used lavishly as a trim or given a full body treatment."[1] This teddy, by the high-end lingerie designer Patricia Fieldwalker, elegantly veils the body by adding wide bands of lace around the exceptionally high-cut leg and deep V-neckline.*

[1] "Tantalizing Teddies," *Intimate Fashion News*
 (January 4, 1988): 4.

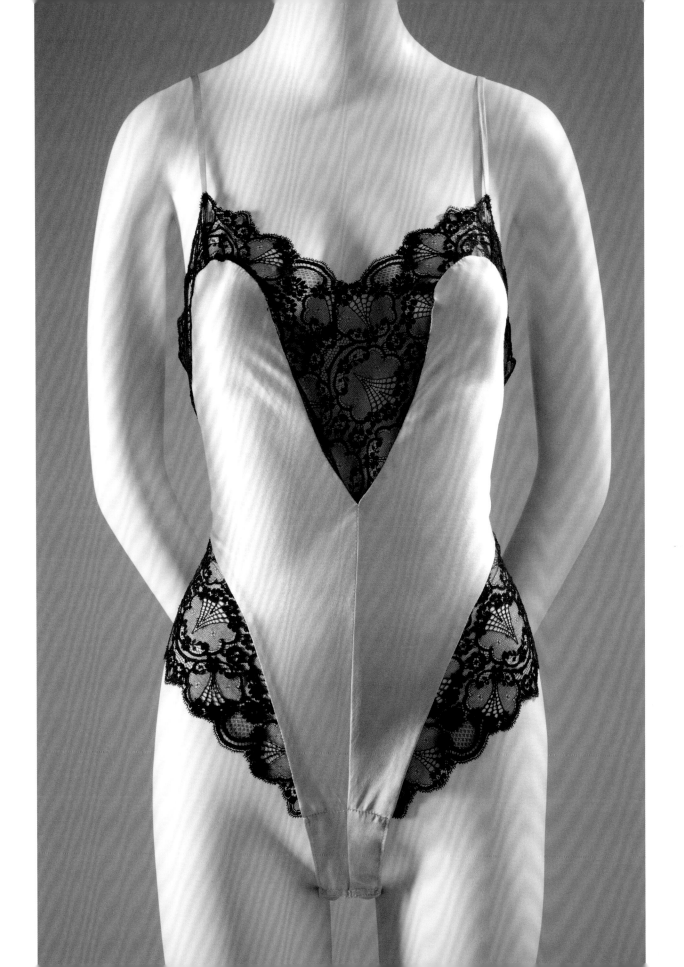

LADY MARLENE BUSTIER / *LACE, JERSEY, SATIN, ca.1988, USA*

Classic lingerie styling was deemed passé in the 1960s, but it had made a comeback by the 1980s. The bustier – an abbreviated, modernized version of the corset – was especially popular. The newer garments were meant to highlight and contain the curves of the fashionable body, toned by diet and exercise, rather than aggressively to mold it. This bustier features light boning over the front of the torso, but relies primarily on a stretch-knit back for a snug fit. It was made by Lady Marlene, a company that specialized in lingerie for weddings and other special occasions.

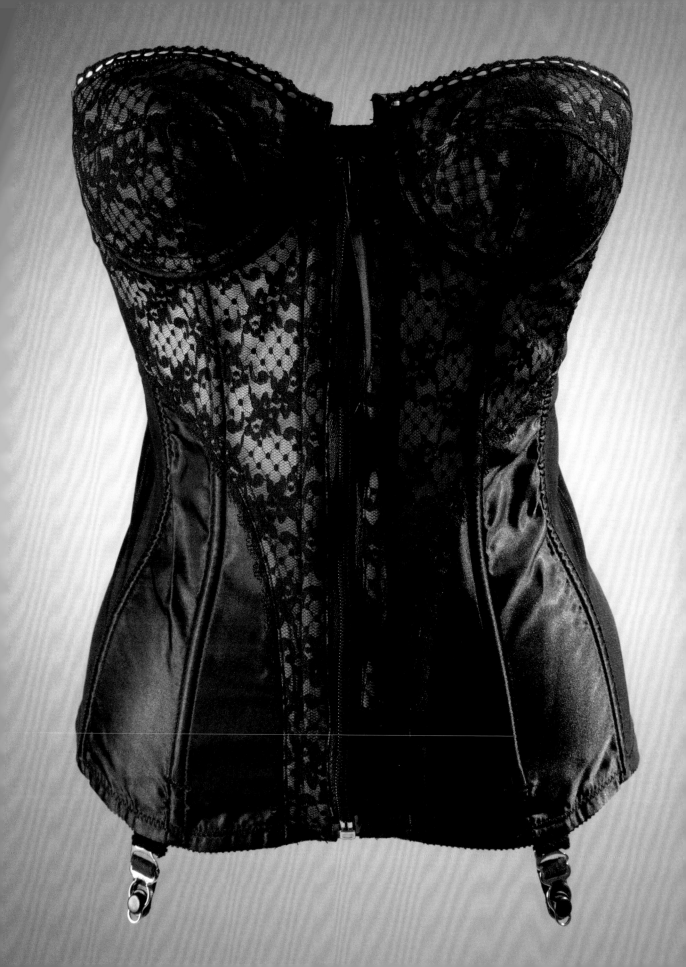

VICTORIA'S SECRET BRA AND PANTY / *LACE, 1990, USA*

Founded in 1977, Victoria's Secret capitalized on renewed interest in ultra-feminine lingerie styles. The company's products were initially available only through mail order, as its founder, Roy Raymond, felt that men would feel more comfortable buying lingerie for their wives via a catalogue.[1] By 1994, Victoria's Secret had stores nationwide, and had grossed $1.8 billion.[2]

The brand's prosperity can be attributed to its ability to produce designs that are stylish yet accessible, sexy without being pornographic. Brightly colored fabrics, such as the teal lace used for this set, have become a hallmark of the Victoria's Secret style.

[1] Jane Juffer, "A Pornographic Femininity? Telling and Selling Victoria's (Dirty) Secrets," *Social Text* 48 (Autumn 1996): 33.

[2] Ibid.: 30.

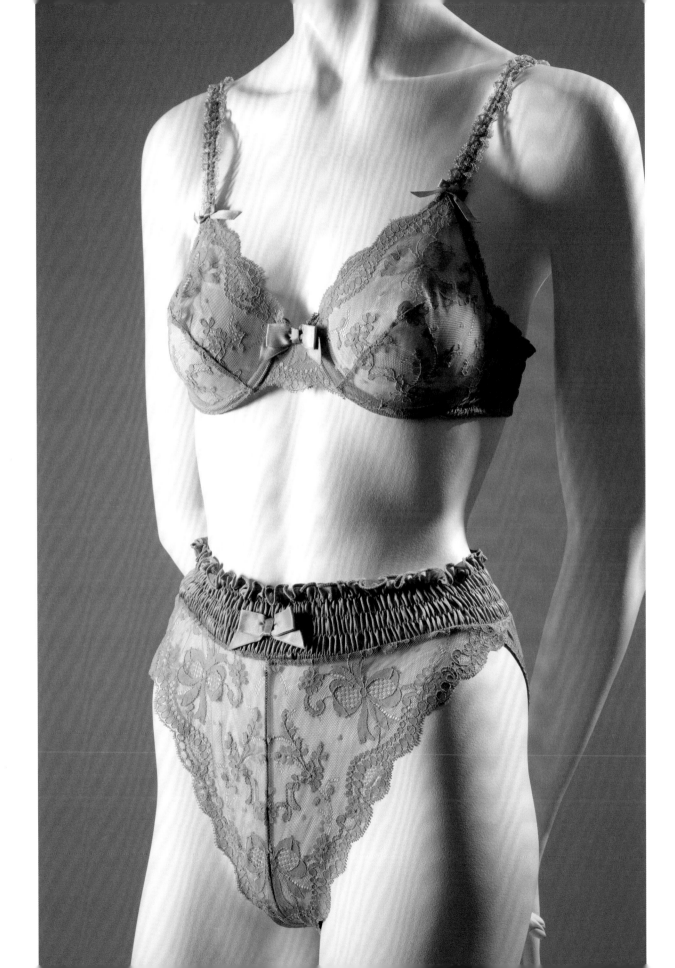

ERICA TANOV SLEEPWEAR ENSEMBLE / *PAJAMAS AND BRA, LINEN, 1993, USA*

Erica Tanov began her career as a sportswear designer and translated her knowledge of casual, functional clothing to her line of sleepwear in 1991.[1] Many of Tanov's designs are inspired by the simple, classic look of her grandfather's silk pajamas.[2] The loosely fitted top and pants of this sleepwear set are clearly based on the designer's interest in men's styles, but the sexy bandeau bra is purely feminine.

Tanov's work is distinguished by its quality and attention to detail. The linen chosen for this ensemble is especially soft, and has been intricately woven in a diamond-weave pattern. The button loop closures are meticulously hand-stitched; Tanov often uses antique buttons from her personal collection.[3]

[1] Karyn Monget, "New Line for Erica Tanov," *Women's Wear Daily* (October 15, 1992): 8.

[2] Karyn Monget, "Erica Tanov's Sleepwear Start," *Women's Wear Daily* (November 7, 1991): 14.

[3] Ibid.

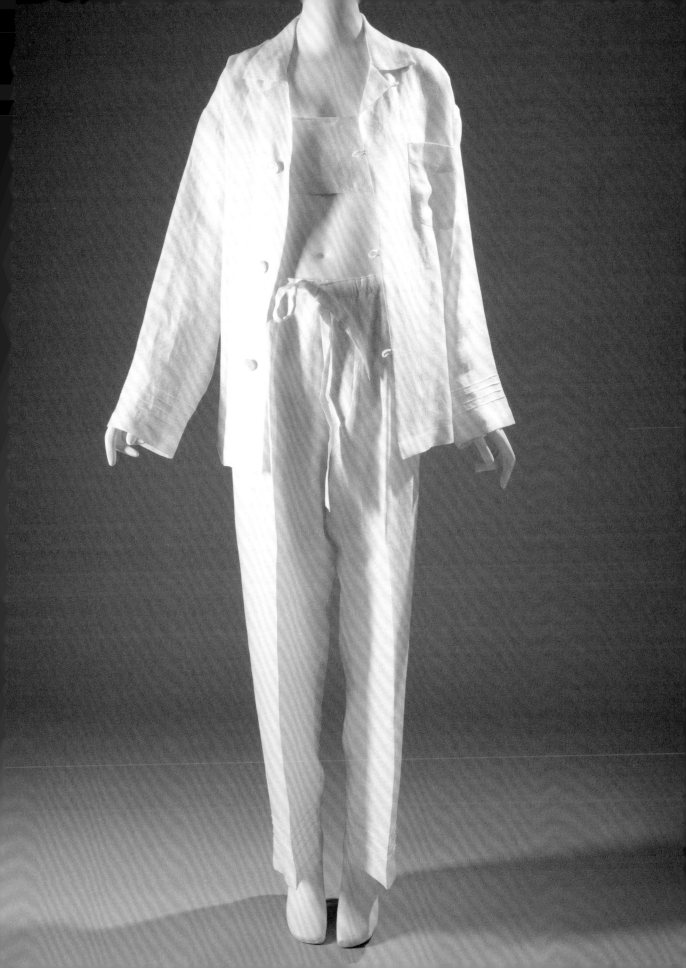

DETAIL of Erica Tanov sleepwear ensemble
Pajamas and bra, linen,
1993, USA

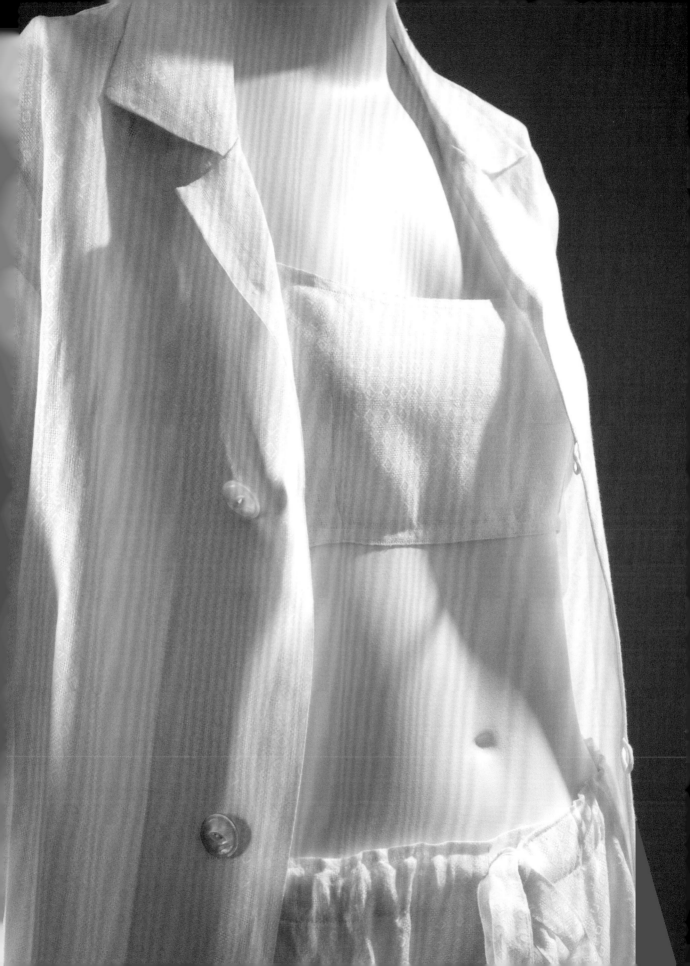

JEAN YU BRA AND PANTY / *SILK CHIFFON, GROSGRAIN RIBBON, SPRING 2005*

Jean Yu began specializing in handcrafted lingerie in 2004. Her unique approach offered a mix of old and new ideas: to create made-to-measure lingerie in a manner similar to that of a traditional couture house, but in styles that were distinctly edgy and contemporary.[1] *While Yu's choice of gauzy fabrics and revealing cuts convey a sense of femininity and fragility, the garments' clean lines are almost stark in their simplicity. She eschews surface decoration, instead turning elements such as black grosgrain ribbon into an integral component of her garments' construction. She uses no underwire or padding.*

Yu often begins her design process by selecting material. In order to maintain the integrity of the fabric, she prefers to cut into it as little as possible, and instead folds or manipulates the fabric to construct the garment.[2] *In this pair of panties, for example, the peek-a-boo, V-shaped front is created using the chiffon's selvedges.*

[1] Nicollette Ramirez, "Jean Yu: Post Millennium meets Classical Grecian Style," *Whitehot Magazine* (Summer 2007), accessed March 25, 2014, http://whitehotmagazine.com/articles/millenium-meets-classical-grecian-style/707 [14].

[2] "Yu's Allure," JC Report (September 7, 2006), accessed March 25, 2014, http://jcreport.com/yus-allure/

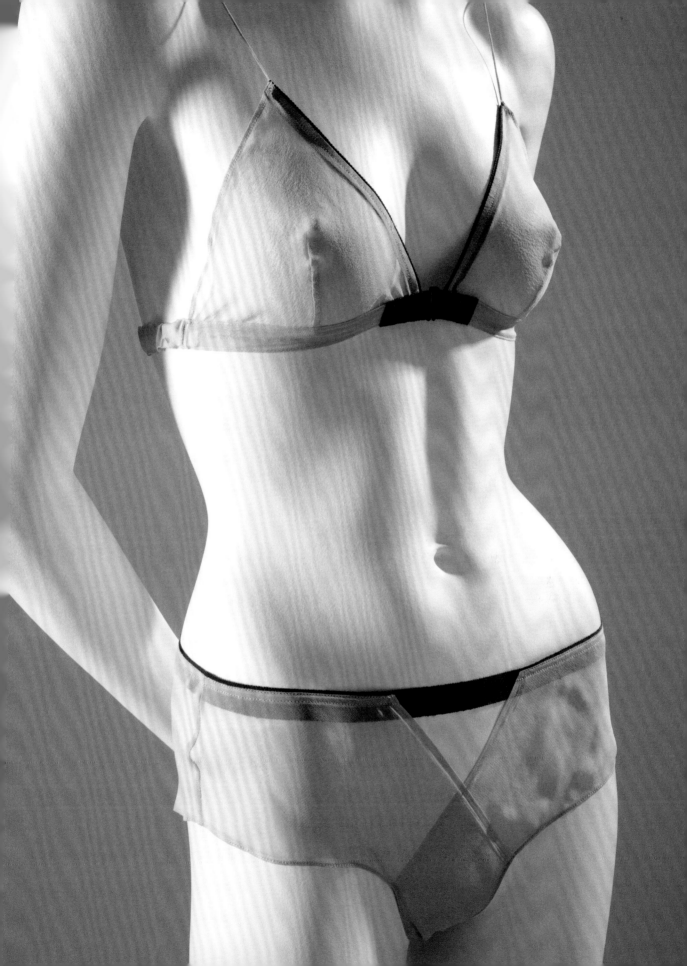

A. F. VANDERHORST ENSEMBLE / *BRA, PANTIES, SUSPENDERS, STOCKINGS, STRETCH SILK, NYLON/SPANDEX, 2006, BELGIUM, "NIGHTFALL" COLLECTION*

Belgian label A. F. Vandervorst presented its first line of lingerie in 2006. That same year, Women's Wear Daily *reported that "[lingerie] looks for next fall have a nostalgic romanticism, with a focus on faded pastels."[1] While the construction and silhouette of this set are retro-inspired, the sharp, contrasting topstitching offers an unmistakably contemporary quality.*

Designers An Vandervorst and Filip Arickx produce their lingerie in France, and they base their designs on the traditions of French corseterie.[2] This ensemble and other undergarments were shown on the runway, interspersed among the designers' outerwear creations – many of which also showed influences from classic lingerie styling.

[1] "Vintage Airs," *Women's Wear Daily* (December 4, 2006): 28.

[2] "About Us," A. F. Vandervorst, accessed March 13, 2014, http://shop.afvandevorst.be/pag281.aspx.

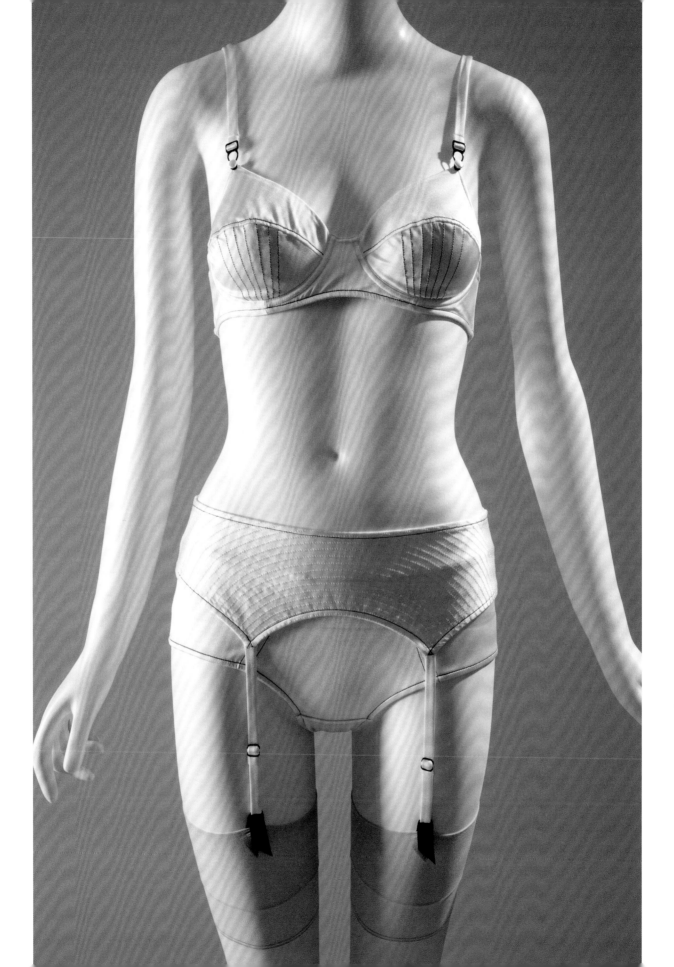

CADOLLE "MALIA" CORSET / *CHANTILLY LACE, COTTON, SPRING 2007*

"The concept of the visible corset has become a socially acceptable form of erotic display,"[1] wrote Valerie Steele in her book The Corset: A Cultural History. *Once perceived as an instrument of female oppression, the corset had taken on new meaning by the 1980s, when designers such as Jean Paul Gaultier and Thierry Mugler adopted it as a symbol of empowerment for women.[2]*

Cadolle has specialized in corsetry throughout its long history. This example is intended to be outerwear, but it can also be worn as an undergarment. The choice of bright pink lace is overtly – and unapologetically – girlish. Rather than using plastic boning, as many contemporary corset manufacturers do, Cadolle corsets are made with steel boning, in various widths and gauges to create a precise silhouette. Whereas plastic can warp due to body heat, steel keeps its shape.[3]

[1] Valerie Steele, *The Corset: A Cultural History* (New Haven and London: Yale University Press, 2001), 170.

[2] Ibid., 166.

[3] Ali Cudby, "What Sets Cadolle Corsetry Apart," *Lingerie Briefs*, accessed March 29, 2014, http://lingeriebriefs. com/2012/03/06/what-sets-cadolle-corsetry-apart/.

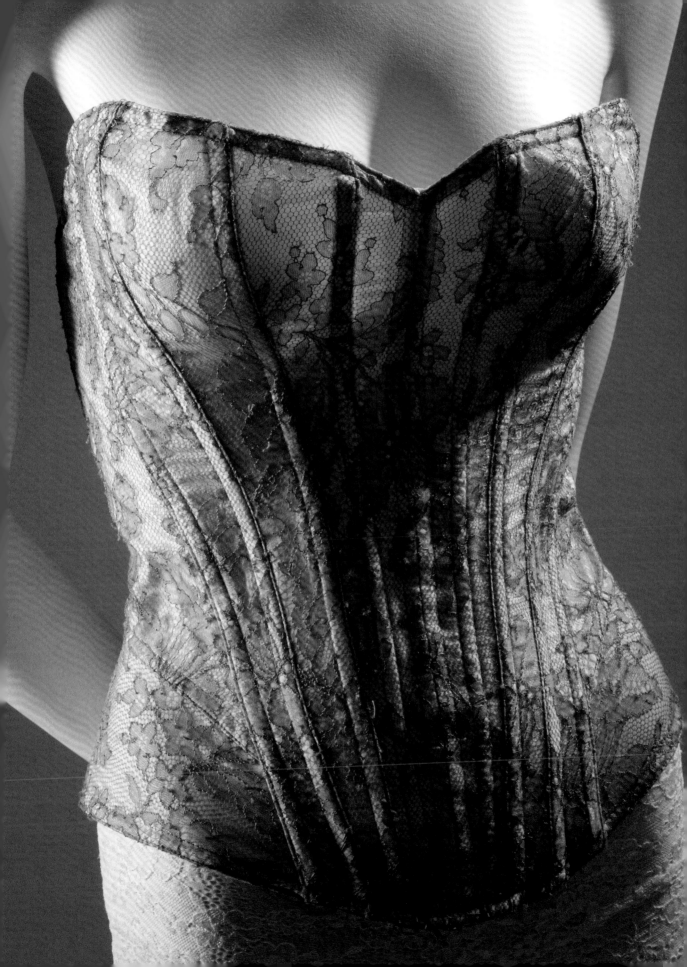

CADOLLE "KYO" NIGHTGOWN / *SILK, 2008, FRANCE*

Herminie Cadolle founded her namesake lingerie line in 1889, and became known for her early, innovative brassiere designs. The company has stayed in the family for five generations, and is now overseen by Poupie Cadolle. It is one of only a few brands that continue to produce made-to-order lingerie – especially bras and corsets – but also maintains a thriving business of high-end, ready-made lingerie and intimate apparel.

Luxury craftsmanship in the French tradition remains integral to Cadolle's designs. This nightgown, in sumptuous iridescent silk, offers a contemporary variation on the feminine "baby doll" styles of the 1950s.

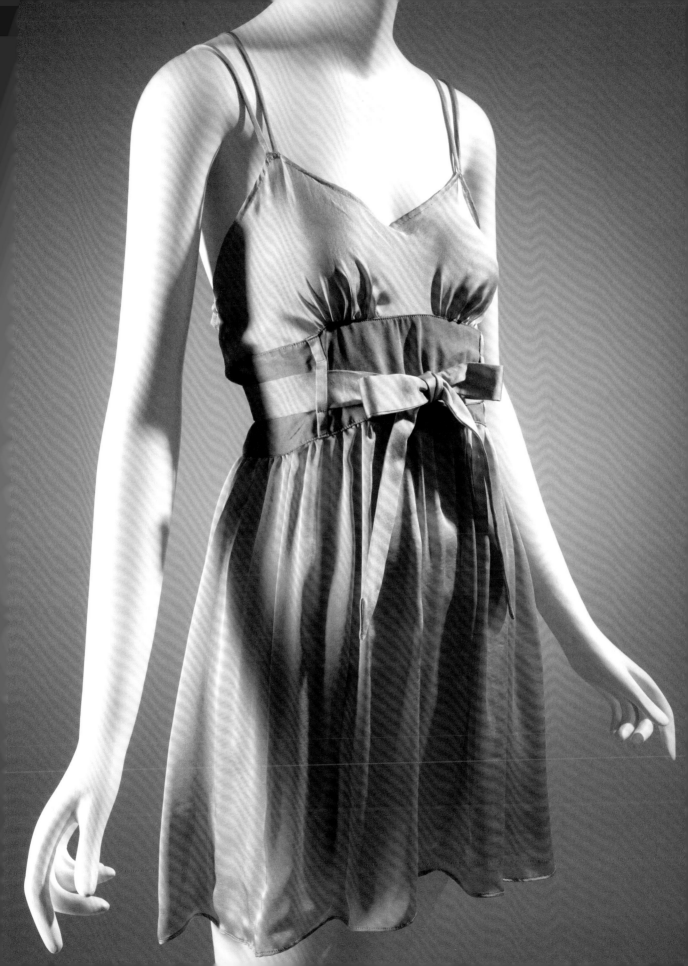

AGENT PROVOCATEUR "ALIYAH" LINGERIE ENSEMBLE / *BRA, THONG, AND SUSPENDERS, LEOPARD-PRINT STRETCH POLYESTER, BLACK RIBBON, 2008, ENGLAND*

"The British have gone lingerie crazy," reported Women's Wear Daily *in 1996,[1] owing in no small part to Agent Provocateur, which opened its first boutique in London's Soho district two years earlier. Founders Joseph Corre and Serena Rees started their business by selling a mix of vintage and contemporary underwear[2] and later focused on their own risqué, retro-inspired lingerie. The label helped to spark a trend for specialty lingerie that has continued into the twenty-first century.*

The son of Vivienne Westwood and Malcolm McLaren – who ran boutiques called "Sex" and "Seditionaries" in the 1970s – Corre is a born provocateur. He and Rees built their label on overtly erotic designs, yet the high quality of their lingerie prevented it from appearing tawdry. Agent Provocateur boutiques have been referred to as "sex shops" for selling whips and pasties alongside bras and panties,[3] but the brand's hyper-sexy image and somewhat scandalous reputation have only strengthened sales.

[1] James Fallon, "In Britain, a Rage for Lingerie," *Women's Wear Daily* (December 23, 1996): 8.

[2] Ibid.

[3] James Fallon, "U.K.'s Provocateur Eyes Growth," *Women's Wear Daily* (January 15, 1998): 10.

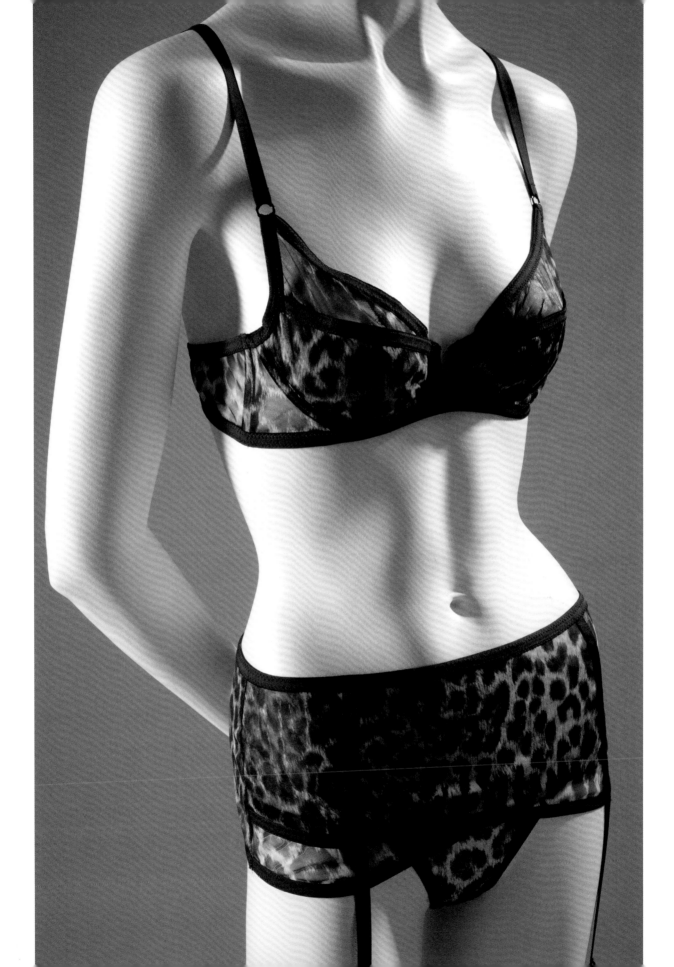

CHANTELLE BRA AND PANTIES / *STRETCH KNIT, LACE, FALL 2013, FRANCE*

Chantelle provides proof that French lingerie has never lost its cachet. The company was founded in 1876 and has now been in business for nearly 140 years. It first made its mark by manufacturing elasticized fabrics that stretched in both directions – an innovative and coveted material among corset manufacturers.[1] During the 1960s, Chantelle's advertising featured bold statements, such as "We Love Breasts."[2]

The company offers lingerie that is sexy and beautifully made, but also suitable for everyday wear. This classic bra-and-panty set exemplifies that point: it is meticulously crafted from two patterns of black lace and edged with an especially fine, scalloped lace trim.

[1] "Heritage," *Chantelle*, accessed March 29, 2014, http://us.chantelle.com/chantelle-heritage.

[2] Karyn Monget, "A Look at Chantelle's Colorful 60 Years," *Women's Wear Daily* (June 8, 2009): 9.

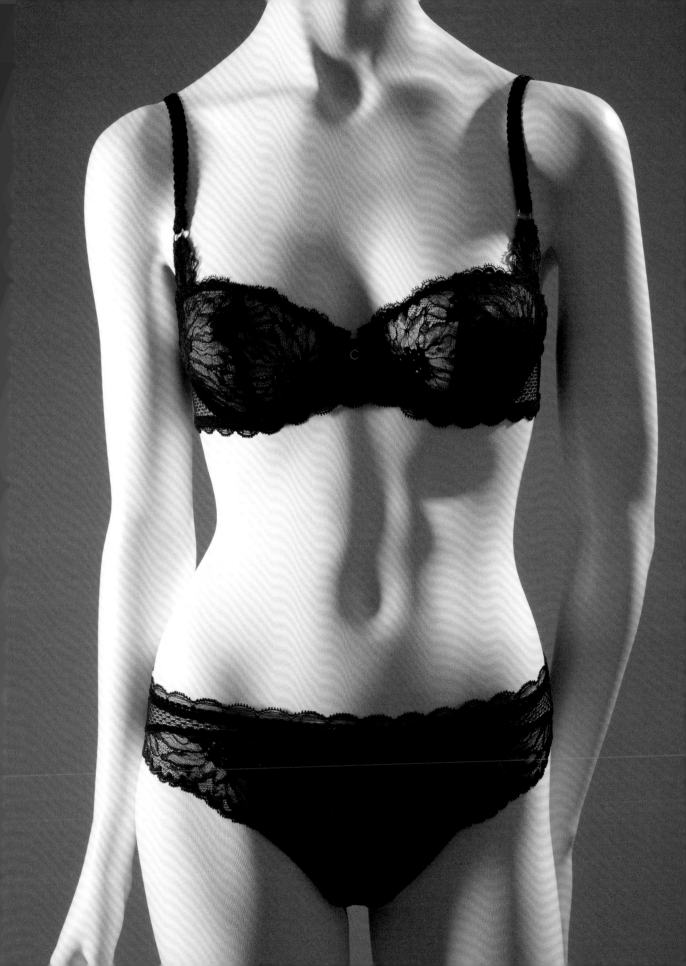

CHANTAL THOMASS ENSEMBLE / *BRA, PANTIES, AND SUSPENDERS, STRETCH KNIT, FALL 2013, FRANCE*

Chantal Thomass was crowned the "French lingerie queen" by Women's Wear Daily – a title earned over a forty-year career in intimate apparel.[1] In 1975, Thomass turned heads when she presented lingerie on the catwalk, audaciously offering romantic, nostalgic designs that opposed the prevailing style for practical undergarments.[2]

Thomass begins her design process by looking through her "archives," a collection of vintage magazines, fabric samples, and undergarments that provide inspiration for her work.[3] Her creations often possess what she calls the "over/under" quality – items that serve their function as underwear, but are also beautiful enough to seen as integral parts of an outerwear ensemble.[4]

[1] Katie Weisman, "Undercurrents: Thomass' Promises," Women's Wear Daily (August 1, 2004): 18.

[2] "The Brand," *Chantal Thomass*, accessed March 29, 2014, http://www.chantalthomass.fr/the-brand/biography-of-chantal-thomass.html#/the-brand/biography-of-chantal-thomass.

[3] Sylvie Richoux, *Women's Pleasures, Chantal Thomass: 30 Years of Creativity* (Marseille: Images en Manoeuvres, 2001), 66.

[4] Ibid., 177.

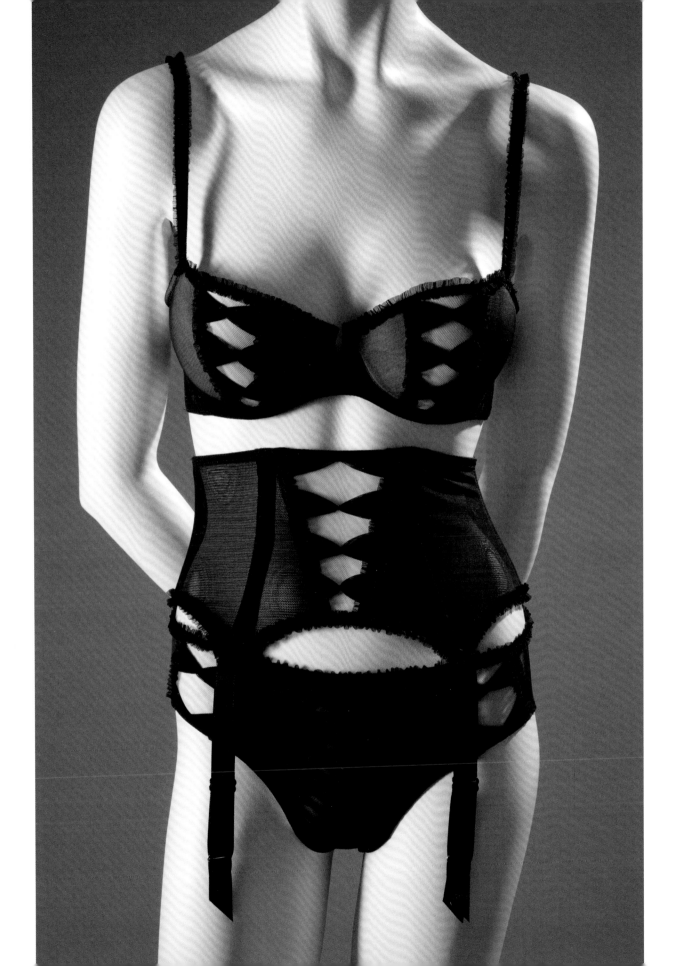

L.A.M.B X HANKY PANKY/ *LAMBIE CAMO RETRO CROPPED CAMI AND LAMBIE CAMO RETRO THONG STRETCH LACE, FALL 2014, USA*

In 1977, Gale Epstein fashioned a bra and panties out of antique handkerchiefs for her friend and neighbor, Lida Orzeck.[1] Epstein's design provided the inspiration – and the name – for the lingerie line, Hanky Panky, that Epstein and Orzeck have operated for over thirty-five years. Initially specializing in g-strings, the company introduced what is now known as "The World's Most Comfortable Thong®" in 1986.[2] Made from stretch lace that allows for a perfect fit and eliminates panty lines, the thong remains one of Hanky Panky's best sellers.

This camisole-and-panty set is part of a collaboration between Hanky Panky and Gwen Stefani's fashion brand, L.A.M.B. The fluorescent camouflage print reveals influence from street fashion – an important element of Stefani's creations[3] – while the set's retro styling underscores both Stefani's and Epstein's appreciation for vintage clothing.

[1] Rosalind Resnick, "Hanky Panky: Building a Business on Empowering Women," www.entrepeur.com, accessed March 27, 2014, http://www.entrepreneur.com/article/220270.

[2] Karyn Monget, "Hanky Panky's Thong Song," *Women's Wear Daily* (June 6, 2011): 12.

[3] "About Gwen Stefani," *L.A.M.B*, accessed March 29, 2014, http://www.shoplamb.com/about-gwen.

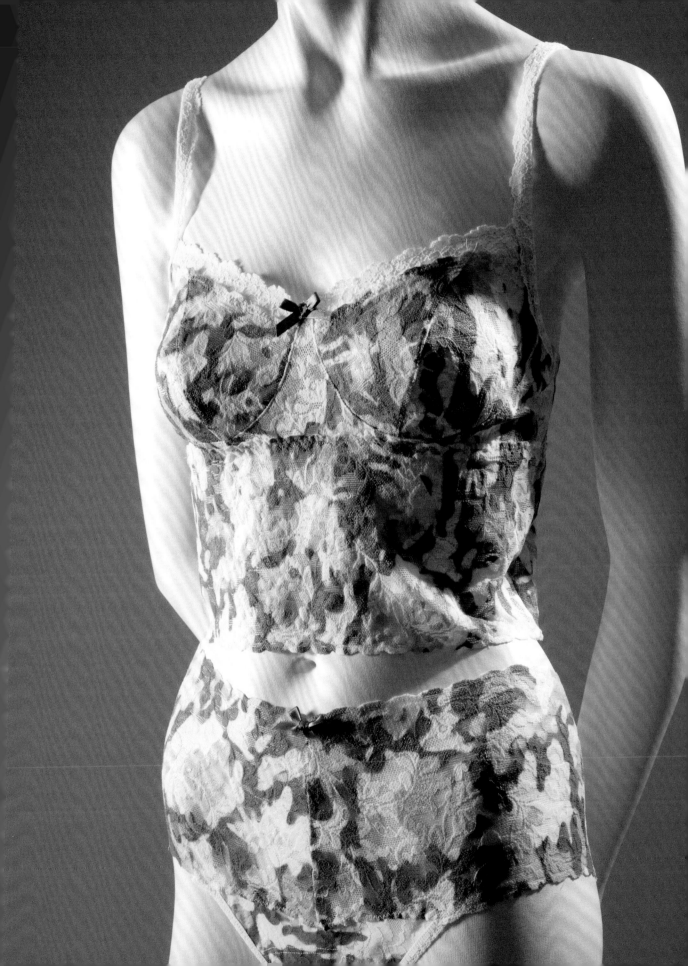

SUKI COHEN (SARAH COHEN) BODYSUIT AND BOLERO JACKET /
STRETCH NYLON, NEOPRENE 2014, COLUMBIA

Launched in 2010, Sarah Cohen's dynamic collection of lingerie blurs the lines between underwear and outerwear. While her bodysuits act as foundation garments, they are also designed to be seen. The young designer's aesthetic is distinctly contemporary: she eschews delicate fabrics and surface embellishments, preferring instead to use deep black, stretch nylon and sharp cutouts that highlight the shape of the female body. The bolero paired with this bodysuit demonstrates her ability to craft more sculptural pieces. Cohen says that her construction technique is "a lot about dealing with different tensions – like engineering for clothing."[1]

[1] Laura Acosta, "Interview: Fashion Designer Sarah Cohen of Suki Cohen," *Beautiful Savage*, accessed March 28, 2014, http://beautifulsavage.com/fashion/interview-fashion-designer-sarah-cohen-of-suki-cohen/.

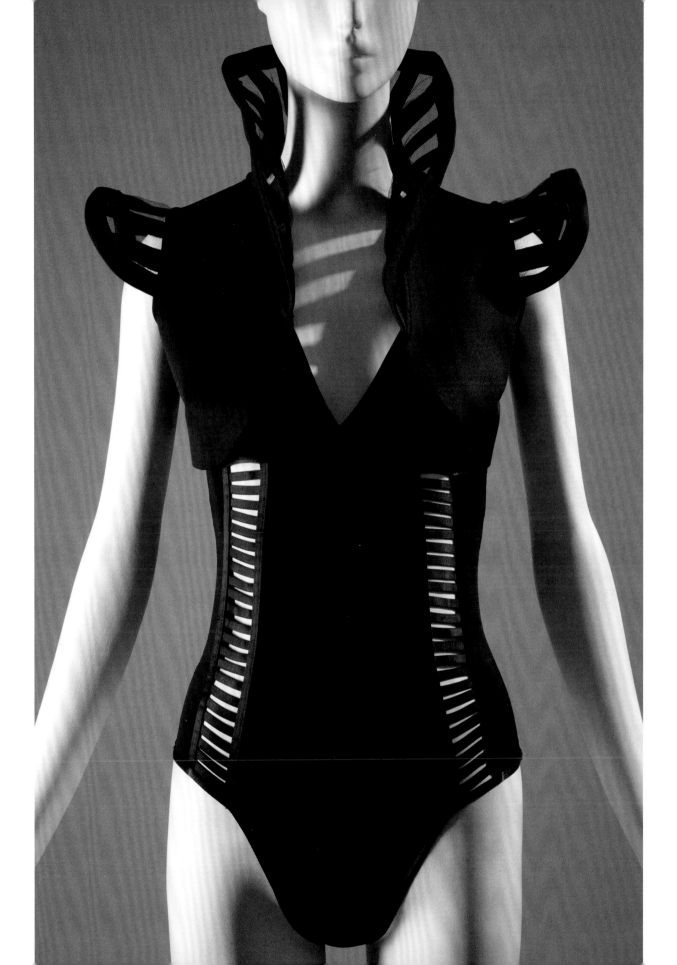

DETAIL of Suki Cohen bodysuit
Stretch nylon
2014, Columbia

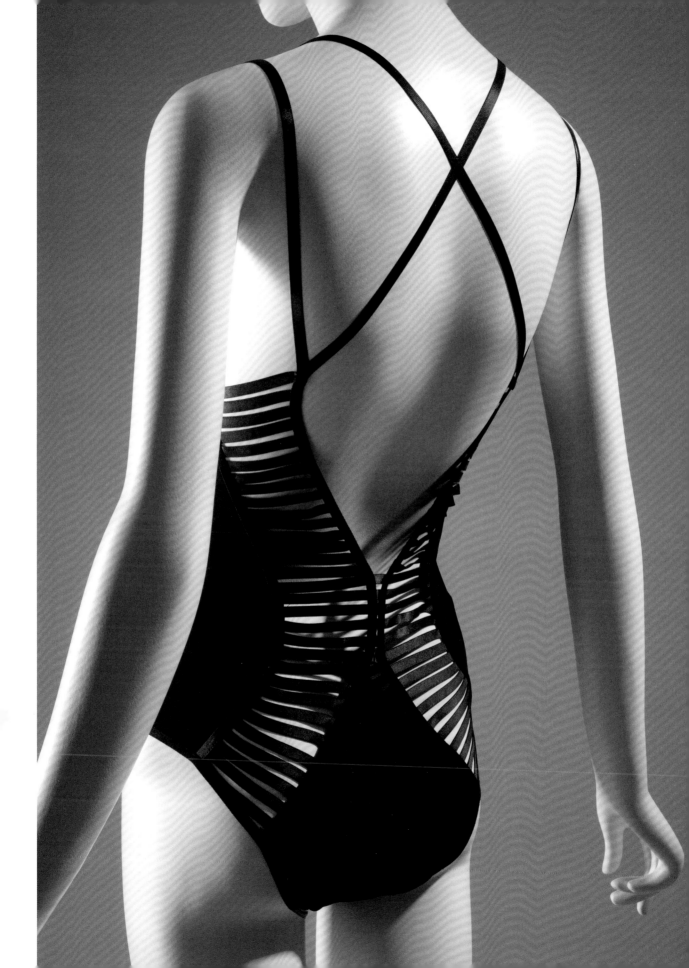

LA PERLA BRA AND PANTY / *EMBROIDERED TULLE SILK, STRETCH SILK SATIN, 2014, ITALY*

La Perla was founded in 1954 by Ada Masotti, a trained corsetière whose skilled hands earned her the nickname "Golden Scissors."[1] *The company name means "pearl" in Italian; fittingly, Masotti carried her designs in velvet-lined boxes, presenting them as if they were jewels for clients to collect. Early La Perla creations focused on brightly patterned silks embellished with lace.*[2]

Bold hues and luxurious materials remain integral to the La Perla aesthetic, as evidenced by this sapphire-blue ensemble made from finely embroidered tulle. The company is now one of the most recognized producers of luxury lingerie worldwide, with advertisements boasting such high-profile models as Cara Delevingne and Liu Wen.

[1] Isabella Cardinali, *Lingerie and Desire: La Perla* (New York: Rizzoli, 2012), 28.

[2] Valerie Steele, *Fashion: Italian Style* (New Haven and London: Yale University Press, 2003), 89.

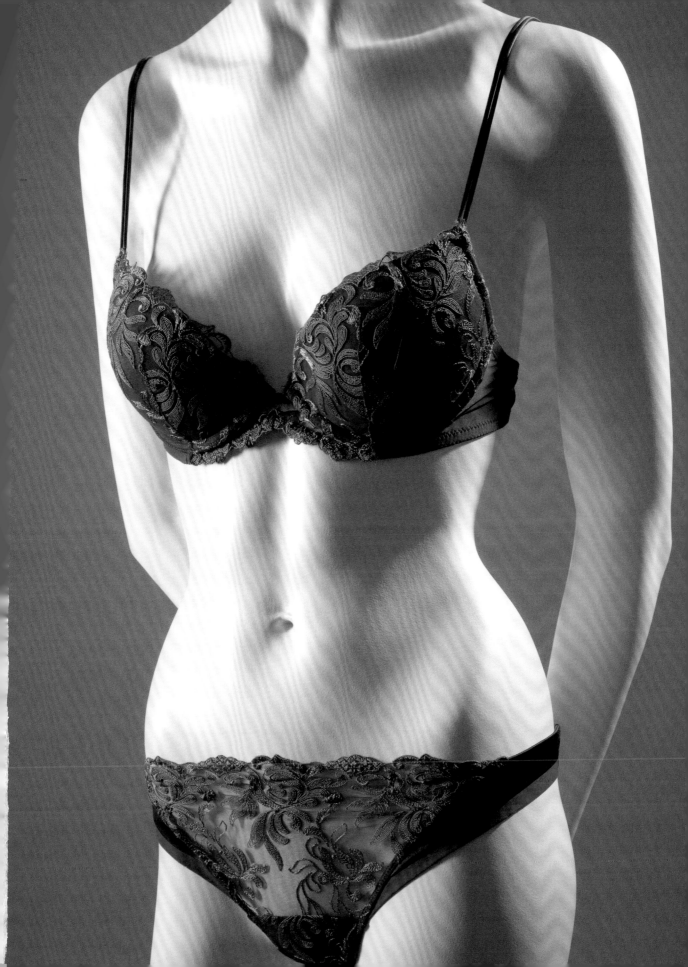

SELECT BIBLIOGRAPHY /

Baumgarten, Linda. *Eighteenth-Century Clothing at Williamsburg.* Williamsburg, Va.: The Colonial Williamsburg Foundation, 2004.

Cardinale, Isabella. *Lingerie & Desire: La Perla.* New York: Rizzoli, 2012.

Chenoune, Farid. *Hidden Underneath: A History of Lingerie.* New York: Assouline, 2005.

Ewing, Elizabeth. *Dress and Undress: A History of Women's Underwear.* London: B. T. Batsford, 1978.

Farrell, Jeremy. *Socks and Stockings.* London: B. T. Batsford, 1992.

Farrell-Beck, Jane, and Colleen Gau. *Uplift: The Bra in America.* Philadelphia: University of Pennsylvania Press, 2002.

Fields, Jill. *An Intimate Affair: Women, Lingerie and Sexuality.* Berkeley: University of California Press, 2007.

—. "Fighting the Corsetless Evil: Shaping Corset and Culture, 1900–1930." *Journal of Social History* 33 (Winter 1999): 355–84.

Finch, Casey. "Hooked and Buttoned Together: Victorian Underwear and Representations of the Female Body." *Victorian Studies* 34 (Spring 1991): 337–63.

Galerie des modes et costumes français. Reprint, Paris: E. Lévy, 1912.

Juffer, Jane. "A Pornographic Femininity? Telling and Selling Victoria's (Dirty) Secrets." *Social Text* 48 (Autumn 1996): 27–48.

Leoty, Ernest. *Le Corset à travers les ages.* Paris: P. Ollendorff, 1893.

Martin, Richard, and Harold Koda. *Infra-Apparel.* New York: Metropolitan Museum of Art, 1993.

Néret, Gilles. *1000 Dessous: A History of Lingerie.* New York: Taschen, 1998.

Richoux, Sylvie. *Women's Pleasures, Chantal Thomass: 30 Years of Creativity.* Marseille: Images en Manoeuvres, 2001.

Steele, Valerie. *The Corset: A Cultural History.* New Haven and London: Yale University Press, 2001.

—. *Fetish: Fashion, Sex and Power.* New York and Oxford: Oxford University Press, 1996.

—. *Fashion and Eroticism: Ideals of Feminine Beauty from the Victorian Era to the Jazz Age.* New York and Oxford: Oxford University Press, 1985.

Barbier, Muriel, Shazia Boucher, and Shaun Cole, *The Story of Underwear.* 2 vols. New York: Parkstone International, 2010.

Uzanne, Octave. *Fashions in Paris.* London: William Heinemann, 1898.

ACKNOWLEDGMENTS /

I am pleased to thank Dr. Joyce F. Brown, President of the Fashion Institute of Technology, for her support of this book and exhibition. I also extend my gratitude to The Museum at FIT's Couture Council and to the Office of External Relations.

I extend very special thanks to Dr. Valerie Steele, director and chief curator of The Museum at FIT, for her continuing support of my work. I am also extremely grateful to Patricia Mears, deputy director, and Fred Dennis, senior curator, for their continued encouragement and advice. I am honored to work with such experts in the field of fashion history.

Many thanks also to my talented colleagues at MFIT for the time and effort they put in to making *Exposed* a reality: the photographer Eileen Costa, for her ability to convey the beauty of the lingerie from the museum's collection; Thomas Synnamon, for his expertise in dressing and styling the garments; and the conservators Ann Coppinger, Marjorie Jonas, and Nicole Bloomfield, for their meticulous work in preparing the objects for exhibition; and to the MFIT publications coordinator, Julian Clark, for his editing expertise and flair for language. Thanks also to the registrars, Sonia Dingilian and Jill Hemingway, for arranging the acquisition of new pieces for this book and exhibition, and to Michael Goitia, Boris Chesakov, and Gabrielle Lauricella of the exhibitions team. To education curators Tanya Melendez and Melissa Marra, for organizing exibition programming, and to media manager Tamsen Young and Mindy Meissen, for giving the exhibition its online presence.

Thanks to Karen Cannell and April Calahan, from the FIT Library Special Collections and FIT Archives, for providing invaluable primary source material. Thanks also to Lizzie Himmel, for allowing us to use Lillian Bassman's beautiful photographs.

I am also indebted to my editor at Yale University Press, Gillian Malpass, for her encouragement and belief in *Exposed*, and to the designer, Paul Sloman, for the elegance he brings to these words and images.

Special thanks to Christopher Howard, for his knowledge and patience as I completed this project. As ever, I am grateful to my family for their faith in me.

Colleen Hill
April 2014